BRIDGING
SCHOOL & HOME
through
FAMILY NIGHTS

BRIDGING
SCHOOL & HOME
through
FAMILY NIGHTS

READY-TO-USE PLANS
FOR GRADES K–8

Diane W. Kyle Ellen McIntyre Karen B. Miller Gayle H. Moore

Skyhorse Publishing

Skyhorse Publishing books may be purchased in bulk at special discounts for sales promotion, corporate gifts, fund-raising, or educational purposes. Special editions can also be created to specifications. For details, contact the Special Sales Department, Skyhorse Publishing, 307 West 36th Street, 11th Floor, New York, NY 10018 or info@skyhorsepublishing.com.

Skyhorse® and Skyhorse Publishing® are registered trademarks of Skyhorse Publishing, Inc.®, a Delaware corporation.

Visit our website at www.skyhorsepublishing.com.

10 9 8 7 6 5 4 3 2 1

Library of Congress Cataloging-in-Publication Data is available on file.

Cover design by Lisa Miller

Print ISBN: 978-1-62914-720-8
Ebook ISBN: 978-1-62914-891-5

Printed in China

Contents

Preface

Why write a book on Family Nights? Currently, schools face new federal and local mandates to involve families in the education of their children. In order to respond, teachers are scrambling for ideas that would be attractive to them and to their students' families. Perhaps you are one of those teachers looking for some new ideas to try out with students and families in your classroom and school. At the same time you know that you already have many expectations in your life as a teacher and little available time. With testing demands, curriculum alignment, professional development, meetings, and more meetings, in addition to all of the day-to-day responsibilities of teaching, you may find yourself concerned about the problem but lacking the resources to address it. We have written this book to help resolve just such a dilemma.

As we begin, we want to introduce ourselves and let you know how we came to write this book. Two of us are university professors (Ellen McIntyre and Diane Kyle), and two of us are classroom teachers (Gayle Moore and Karen Miller). We have worked together as part of a research team for several years as we studied an educational reform initiative in our state and effective instructional strategies for improving students' academic achievement. Especially interested in how to support those students often not successful in schools, we devoted considerable effort to finding ways of reaching out to families and involving them more meaningfully and extensively in their child's education.

Our research took us into the homes of families to learn from them about their children. We organized Family Nights, redesigned homework, focused on new ways of communicating, and changed some instructional practices. After several years of this work, we decided we were ready to share some of what we had tried and learned. Corwin Press, Inc., published our book, *Reaching Out: A K–8 Resource for Connecting Families and Schools* in 2002. One chapter in the book offered examples of Family Night activities.

We have shared the ideas in the book as we have worked with teachers and principals in our university classes, statewide literacy projects, and

AUTHORS' NOTE: The research that led to the writing of this book was supported under the Education Research and Development Program, PR Award Number R306A60001, The Center for Research on Education, Diversity, and Excellence (CREDE), as administered by the Office of Educational Research and Improvement (OERI), The National Institute on the Education of At-Risk Students (NIEARS), U.S. Department of Education. The contents, findings, and opinions expressed here are those of the authors and do not necessarily represent the positions or policies of the OERI, NIEARS, or the U.S. Department of Education.

professional development sessions. They have responded very positively to all of the strategies. However, they have gravitated most often to Family Nights when choosing a family involvement initiative to try in their own settings. We decided that a book solely devoted to Family Nights would fill an expressed need for teachers. Further, we realized that, by developing Family Nights on topics across the curriculum, we could help teachers meet their academic goals as well.

In writing this book we hoped to offer as much assistance as possible for planning and implementing the events, while also providing the flexibility to make modifications to meet teachers' needs in a particular context. Although the standards of professional organizations and the mandates of federal legislation provide common influences on schools across the country, teachers in those schools still make decisions in light of their own experiences, resources, and goals and with particular students and families in mind. We have a deep respect for teachers as professionals (after all, we're teachers, too) and reject attempts to "teacher-proof" curriculum materials. We have provided a wealth of ideas and resources, knowing that teachers will modify and supplement as needed, adding their own creativity to enrich the Family Nights and make them as meaningful as possible for their students' families.

The book includes an introduction, 13 chapters of Family Nights, and a follow-up chapter about expanding on these ideas. The introduction elaborates on the key reason for Family Nights—to improve student achievement through involving families in schools and as partners in students' education. It also includes information on how to use the book most effectively, adaptations for special populations, issues about providing food and incentives, and cost-saving ideas. Each of the 13 chapters is a self-contained unit, including all information, suggestions, and materials needed for implementing a particular Family Night. Each provides a purpose statement, connections with national professional standards, and an overview of the content and grade level appropriateness. Teachers can find detailed help on how to organize the evening, including procedures, an agenda, needed materials, tips, and how to follow up with families unable to attend. Reproducibles for each Family Night include an invitation, a blank agenda, a blank sign-in sheet, and an evaluation form, as well as materials specific to the topic for use with overheads or as handouts. Any resources listed at the end of a chapter offer additional sources of information teachers would find helpful.

These Family Night experiences offer an enjoyable and academically meaningful way for schools to reach out to families and get them involved. Although the ultimate goal may be more far-reaching, Family Nights provide an important first step. It is up to us to make that first step worth taking.

● ACKNOWLEDGMENTS

Our work with families over the past several years involved us in many activities, including Family Nights such as those described in this book. We are very indebted to those families. They helped us to realize the value of these events as ways in which schools and families can learn from one

another and, in partnership, help students achieve. We also thank the Center for Research on Education, Diversity, and Excellence (CREDE) for funding our research that resulted, in part, in the development of this book.

We thank several reviewers who took time to read the manuscript with such care and whose suggestions helped us to strengthen the final version. And, once again, we appreciate the enthusiasm, support, and assistance that Rachel Livsey and Phyllis Cappello of Corwin Press, Inc., have provided through all phases of the process.

Thank you to Héctor Amado Sánchez Martínez and Esaú Ruiz Acevedo for translating the invitations to Spanish.

The contributions of the following reviewers are gratefully acknowledged:

Patricia B. Schwartz
Principal
Thomas Jefferson Middle School
Teaneck, NJ

Susan N. Imamura
Principal
Manoa Elementary School
Honolulu, HI

Joy Dryfoos
Independent Writer
Brookline, MA

Michele R. Dean
Principal
Montalvo Elementary School
Ventura Unified School District
Ventura, CA

Ellen Lunts
Assistant Professor/Mentor
Master of Arts in Teaching Program
Empire State College
Rochester, NY

About the Authors

Diane W. Kyle is a professor in the Department of Teaching and Learning at the University of Louisville. She has coauthored *Reaching Out: A K–8 Resource for Connecting Schools and Families* and *Reflective Teaching for Student Empowerment: Elementary Curriculum and Methods*, coedited *Creating Nongraded Primary Classrooms: Teachers' Stories and Lessons Learned*, and published in such journals as *Language Arts, Peabody Journal of Education, Journal of Education for Students Placed at Risk, Education & Equity, Teaching Children Mathematics*, and *Elementary School Journal*. Her most recent project, codirected with Ellen McIntyre, is "Sheltered Instruction and Family Involvement: An Approach to Raising Achievement of LEP Students," funded by the U.S. Department of Education. She also codirected with Ellen McIntyre a research project, "Children's Academic Development in Nongraded Primary Programs," funded by the Center for Research on Education, Diversity, and Excellence (CREDE) at the University of California at Santa Cruz. An important aspect of this research was the focus on school–family connections. Insights from this research provided the motivation for developing this book.

Ellen McIntyre is a literacy professor in the Department of Teaching and Learning at the University of Louisville, where she teaches courses on literacy research and instruction and studies children's development in light of instructional contexts. She has published extensively, having coauthored *Reaching Out: A K–8 Resource for Connecting Schools and Families*, coedited *Classroom Diversity: Connecting School Curricula to Students' Lives, Balanced Instruction: Strategies and Skills in Whole Language*, and *Creating Nongraded Primary Programs*, and published in such journals as *Language Arts, Research in the Teaching of English, Journal of Literacy Research*, and *American Educational Research Journal*. Her most recent project, codirected with Diane Kyle, is "Sheltered Instruction and Family Involvement: An Approach to Raising Achievement of LEP Students," funded by the U.S. Department of Education. She also codirected with Diane Kyle a research project, "Children's Academic Development in Nongraded Primary Programs," funded by the Center for Research on Education, Diversity, and Excellence (CREDE) at the University of California at Santa Cruz. An important aspect of this research was the focus on school–family connections. Insights from this research provided the motivation for developing this book.

Karen B. Miller has taught elementary school for more than 20 years in grades 1–4. She currently teaches at Roby Elementary in Bullitt County, Kentucky. For two years, she participated as a teacher-researcher on the study, "Children's Academic Development in Nongraded Primary Programs," funded by the Center for Research on Education, Diversity, and Excellence (CREDE) at the University of California at Santa Cruz. Making family visits during this time enabled her to learn more about the students in her classroom and to make connections in her instruction, often through Family Nights she planned and implemented. She has co-authored *Reaching Out: A K–8 Resource for Connecting Schools and Families* and presented for several years at the National Reading Conference. In addition, she has served as a teacher leader for the Kentucky Reading Project and Project READ Early Intervention, in which she has provided intensive professional development for teachers on literacy and family involvement. She also has presented at the National Reading Conference on home–school connections.

Gayle H. Moore recently retired after teaching elementary school for 31 years at grades K–8, including 9 years in the nongraded primary program at LaGrange Elementary in Oldham County, Kentucky. Throughout that time, she participated as a teacher-researcher on studies related to the nongraded primary. She has coauthored *Reaching Out: A K–8 Resource for Connecting Schools and Families*, a chapter in *Creating Nongraded Primary Classrooms: Teachers' Stories and Lessons Learned*, and articles in *Language Arts* and *Peabody Journal of Education*. She has presented at conferences of the American Educational Research Association, the International Reading Association, and the National Reading Conference. Most recently she has participated as a teacher-researcher for the study, "Children's Academic Development in Nongraded Primary Programs," funded by the Center for Research on Education, Diversity, and Excellence (CREDE) at the University of California at Santa Cruz. For three years, she made family visits to the homes of her students, learning about the families' knowledge and using it to make instructional connections. She also planned and implemented several Family Nights, one focused on mathematics. Her subsequent classroom activities are described in an article in *Teaching Children Mathematics*.

1

Getting Families Involved Through Family Nights

The primary purpose of holding the Family Nights described in this book is ultimately to improve students' academic achievement. The more parents and families understand and take part in their child's school work and activities, the more likely that child will succeed academically. And the more deeply teachers get to know their students and their' families, the better they can teach to their students' individual needs.

Yet, as our student population becomes increasingly diverse, we face a daunting challenge in establishing close connections with their families. Many teachers work with students unlike themselves in race, culture, class, language, and religion. Our democratic ideal of educating all students well and increasing their potential to be productive, contributing, and successful citizens requires that we make every effort to do whatever is needed. Working in partnership with families is a critical component of that effort, and the Family Nights described in this book offer a good place to start. However, developing partnerships means paying attention to what we know about how to build relationships.

Joyce Epstein, one of the leading voices on family involvement, and her colleagues (Epstein, Coates, Salinas, Sanders, and Simon, 1997) outlined

six different ways family involvement occurs: (1) parenting education; (2) communicating better between home and school; (3) volunteering in schools; (4) learning at home; (5) decision making; and 6) collaborating with the community. The Family Nights we offer encompass some aspects of three of these ways of involving families: communicating volunteering, and learning at home. They can also extend to collaboration with the community.

The work that we recommend is research based. Indeed, much recent research has shown the positive effects of family involvement (Clark, 2002; Marcon, 1999; Sanders and Herting, 2000; Shaver and Walls, 1998). Studies have also shown that, while parents care about their children's education and want them to be successful (Epstein, 1987; 1995; Sanders and Epstein, 2000), some are uncertain about how to be involved and some feel unwelcome or misunderstood when they visit schools. Further, it is often families from poor or working-class groups or cultural minorities that are least understood by schools.

In one recent review of the research literature on diverse families and their involvement with schools (Cooper, Chavira, and Mena, 2004), researchers looked at why, across grades K–12, our schools lose more and more students from ethnic and racial minority groups. The studies in the review illustrated that families are a key factor—and possibly the most important one—for developing and sustaining students' educational and career aspirations. Although expected among college-educated parents, low-income, minority, and immigrant families often inspire and help their children to set and maintain these aspirations as well. Many minority and low-income parents have goals of college and work long hours to support dreams of a better life for their children. However, parents who have not attended college in the United States may not know specific steps for realizing these dreams.

This review also showed that families remain crucial to student success through middle and high school, a period that many teachers consider to be a time when youth want autonomy. Peers were shown to be important, but they were not always challenges; they often served as resources for keeping children in school. One of the studies included in the review (Chang, 2004) involved middle-school students doing Family Nights much like the ones we propose in this book.

With the goal to improve students' education through a home-school collaboration, Chang (2004) and her school partners targeted low-performing, language minority sixth graders for a project called "Family Literacy Nights." The teachers held two 2-hour literacy nights three weeks apart (for two different groups) with the goals of building support and learning specific instructional strategies that were emphasized in school. The project began with professional development for the teachers, and it was the commitment of the teachers and the leadership of a few that contributed to the project's success. The teachers taught the families of their targeted population the same strategies they used in school that could be transferred to home learning contexts.

Another study reviewed by Cooper, Chavira, and Mena (2004) was conducted by the authors of this book. In that study (Kyle, McIntyre, Miller, and Moore, 2002) teachers and researchers collaborated to understand children's development in and out of school. We knew we needed to get to know the students deeply; thus, our work took us into the homes

and communities of the students we taught, and we began to look for ways to build strong relationships with the parents, guardians, or families. A pattern across all the families we studied was that they all faced challenges in their personal lives that (for some) seemed to affect their performance in school. Yet, like all the studies in the review conducted by Cooper, Chavira, and Mena (2004), the families in our study cared deeply about education.

Among the major findings from our study was that effective relationships build from a sense of trust, no matter whether they are personal or professional relationships. Parents and school personnel must trust that each has the best interests of the children at heart and a desire to work together for those children. How does that trust develop in the first place? Only by spending time together, getting to know one another, and understanding each other's perspectives and experiences. This may not mean everyone agrees or shares the same view, but trust happens when people feel known and respected in spite of their differences.

The Family Nights we propose offer a way to both convey and nurture trust with families and to build respectful and effective relationships. This is done in several ways across all events:

- Opportunities for families to share from their own experiences and knowledge
- A focus on learning *from* as well as *with* families
- Activities that engage participants, not merely talk to them
- A range of topics to capture families' diverse interests
- Food provided to accommodate families' busy schedules
- Attention paid to the needs of those who struggle with reading and writing
- Attention paid to the needs of those who are learning English
- Attention paid to the needs of those with physical disabilities
- Adaptations for children with special gifts and talents
- Follow-up for those unable to attend
- Products that can be used at home and/or be displayed in the school
- Scheduling flexibility to maximize involvement of all families

HOW TO USE THIS BOOK ●

As you begin to use this book, you might want to take a look at all of the topics and think about your curricular goals for the year, your school's emphasis and needs, your own personal interests and strengths, and other resources that might already be available to you. Select a Family Night topic to begin with that fits well with these considerations and also is likely to spark interest in your students and their families.

Then, use the "Planning Guide" (see Resource A) provided and add anything you might need to take into account that is specific to your own setting. Involve the students! When they help to plan and get excited about the event, they are more likely to urge their families to attend.

Although you will find a wealth of ideas in each chapter, enough to implement each Family Night, you can add to or modify any of the reproducible materials or activities. In this way you can make the Family Night

more reflective of the ongoing work in your particular school or classroom. For example, let's say your school has a schoolwide focus on environmental issues one year because of a local "Clean Up Our Community" campaign. This theme could easily be adapted in the activities of many of the suggested Family Nights, not only the obvious ones such as science, math, and health and wellness, but also those less immediately obvious, such as those on poetry and famous people. It just would take a little extra planning time and creativity.

You could consider any number of "road maps" in using the Family Night chapters in this book. For example, you could select the reading, writing, poetry, and pajama party Family Nights for a focus on literacy. Or, you could select just one of those and then ones on math, science, and social studies for a focus across the curriculum. Depending on your community, you might begin with a family traditions or scrapbook event. The idea is to use the Family Night plans in ways that best meet the needs in your context.

We call these events "Family Nights" because most of the teachers we know schedule them in the late afternoons and evenings. However, depending on when the families in your school might be most likely to attend, you could just as easily have a "Family Saturday Morning" event, similar to our suggested "Math Morning." Furthermore, if you are planning these in collaboration with other colleagues in your school, you could plan several of the topics for one evening. This would allow the families to sign up for the one they are most interested in attending.

Although the book will help you implement Family Nights on your own with the children and families in your classroom, involving others from your school and resource people from your community can help to develop more ideas and materials for activities and provide assistance during the event. Keep in mind, too, that the families themselves can be this kind of resource. Once you have provided a few Family Nights and generated enthusiasm among the families, think about inviting them to nominate other topics or help in the planning process. Remember that the larger goal is the involvement of the families in more than just Family Night events. Family Nights can be a start, an important entry point for many who have not been involved in more traditional ways.

Some might wonder whether these Family Night ideas would work in schools of high poverty, where getting families involved is sometimes a challenge. We have implemented most of these plans in schools with just those characteristics and found the response to be overwhelmingly positive. Why? We think it is because the approach is respectful of families and very invitational, the topics are meaningful and interesting, and the activities are engaging. We feel sure you will have similar experiences.

In Resource A we provide some overall tips to keep in mind as you plan your Family Nights. However, four topics in particular should be mentioned now. First are the adaptations that can be made for special populations.

● ADAPTATIONS FOR SPECIAL POPULATIONS

For families with members with physical disabilities, be sure your school is handicap accessible. A phone call home asking the parents what they might need in order to attend would be a welcoming gesture.

For family members with adults who struggle with reading and writing, recognize that the Family Night/Morning invitations and other home-school correspondence might not be read. We therefore recommend that teachers teach their children to read the invitations to the adults as extra reading practice.

For those families with members with reading or other learning disabilities, some of the Family Nights may seem daunting and unwelcoming. Be sure to communicate to the adults that they will *not* have to read or write themselves but all family members will be asked to help out during the activities.

For families with members who are learning English, an extra invitation may be needed. The Internet provides multiple sources for translating English into other languages. For example, at www.paralink.com, you can type in a message, select a language, and—voilà!—the program translates your invitations. For families who may have very low literacy skills in their first language, you may want to find a way to meet with them with an interpreter. If this is not possible, be sure to include gestures and visuals and speak slowly. This effort can go a long way toward helping families comprehend and participate. During the Family Nights, if possible, greet the family in their first language. Use gestures, visual aids, and speak slowly and distinctly using everyday words. The families will probably understand more than you think (without being able to produce the words to let you know), or they may find someone who can further explain (often their own children). The key is to not make the families feel left out; you want to communicate to them that you want them there.

BE THOUGHTFUL ABOUT FOOD PROVIDED ●

Another issue has to do with food. For each Family Night we have suggested having food for the participants as either meals or snacks. We urge you to have as many healthy options as possible. The Health and Wellness Family Night focuses on this importance specifically, but we think it is desirable to demonstrate the same commitment to making healthy choices at all Family Nights. Remember to have choices for vegetarians who might attend, and be considerate of participants' religious beliefs. Also, follow any school policies that address concerns about food allergies and know enough about the ingredients in what is served to answer questions from those attending.

BE CAREFUL ABOUT INCENTIVES ●

One of the overall tips for planning Family Nights mentions the use of door prizes. We know this is a common practice and can provide an incentive for some families to attend. Keep in mind, though, that young children have not learned the concept of "chance" and always expect to win. Door prizes at the end of the evening can result in some children leaving unhappy.

● COST- AND TIME-SAVING IDEAS

Teachers always seem to find creative ways to save money and get resources for their classrooms. No doubt you can think of many ways to save costs and time in putting on Family Nights at your school. A few ideas to consider are: ask families for contributions, especially after you have had a couple of Family Nights and they are eager for more; look for yard sale treasures; do not be shy about asking for help—seek donations from businesses (restaurants might provide plates, napkins, and cups, or grocery stores might provide day-old food items) and ask your principal about any available school resources (often money set aside for after-school programs or other funds can be used for such purposes); write a proposal for available grants from foundations or other sources in your area; and be on the lookout for materials that could be used in a creative way for a Family Night activity.

In addition, perhaps you could set aside some of your classroom instruction money to use throughout the year and design class projects that could help raise money for Family Nights. For example, have students design and make stationery to sell, open a floral shop and sell flowers throughout the school (handmade flowers), ask for soft drink machine money, ask your PTO or PTA organization for help, or ask your students to donate money that they have earned by, say, doing chores at home.

Also remember that you can actually do these events with almost no cost at all, except in time. If you hold the event at a nonmeal hour, you do not have to provide food. Just let the families know ahead of time. Also, materials can be those you regularly use in the classroom.

Above all else, just get started. Our own experiences and those of the many teachers we have worked with convince us that you, too, will find Family Nights an enjoyable and beneficial way to get to know your students and their families in deeper and better ways. From these positive experiences together we believe that you will have increased parent participation, stronger partnerships in meeting your students' needs, and better teaching and learning in the classroom.

2
Scrapbook Family Night

*Preserving Memories
in Words and Pictures*

WHY DO SCRAPBOOK FAMILY NIGHT? ●

People of all ages have life experiences they want to remember and share with one another. Families share many great times but also have memories of events that have occurred elsewhere with friends and in years past. It is important for people to "record" these meaningful times so that they can be shared, preserved, and remembered.

The Scrapbook Family Night is a wonderful event because it allows families to take the time to reminisce and keep the shared experiences alive through the pages of a scrapbook. Not only does it encourage families to think about and tell their stories to one another, it also allows families to share with other families. Realize too that this also could be a time for each family to share a literacy event. The atmosphere is casual and conversational as families record their great memories on their scrapbook pages. This creates an opportunity for getting to know each other. It might be a good one to start off the year with, as relationships are being formed.

Families are asked to bring in photographs that they might like to use along with the cutouts, stickers, stamps, art supplies, and pages that the teachers provide for use. Some families may want to work on a few pages that evening and finish the rest at home, while others may want to complete

the entire scrapbook that evening. The true value is in getting everyone involved in creating this family treasure.

Author Miller has conducted several Scrapbook Family Nights and believes doing it at the beginning of the school year is the best time. The invitation to bring in old photographs and other materials is usually a draw for families because it is a risk-free way to come into the school. Miller had all materials spread out on tables before the families arrived. When the families were convened, Miller explained each of the model pages (a sample page is enclosed in this chapter) and illustrated possibilities for decorating them. The families immediately got started working on their scrapbooks, talking with other families as they worked. Miller liked this workshop for early in the year because, once the workshop was prepared, she had no direct role and could move from table to table admiring photos and other keepsakes and asking questions of the families. Some families felt they couldn't leave until they had every page done, while others did a few pages and left to finish them at home. Overall, it was lighthearted, casual, and a nice chance to get to know one another.

We encourage you to adapt the Scrapbook Family Night ideas to your students, families, and community. For example, you might want to include a page or pages that reflect an important part of your community, or a certain event or place that most people know or are connected with might warrant its own page. Encourage everyone to enjoy the actual making of the scrapbook and the sharing of their lives.

Purpose

The purpose of Scrapbook Family Night is to provide an opportunity for families to make a scrapbook that records important events of their lives.

Connections to National Standards

Like all of the Family Nights in this book, this one addresses academic standards. The National Council of Teachers of English (NCTE) and the International Reading Association (IRA) standards (2002) included in this family night are

Students adjust their use of spoken, written, and visual language to communicate effectively.

Students participate as knowledgeable, reflective, creative, and critical members of a variety of literacy communities.

Students use spoken, written, and visual language to accomplish their own purposes.

Content of Scrapbook Family Night

In this Family Night, the teacher shares a scrapbook page previously created that reveals an event in her life. This provides a model for the families. The teacher then shows a blank scrapbook to the group, so they understand the variety of pages they have the opportunity to work on. The teacher instructs the families to work together as they write, illustrate, and/or decorate

each page so that it captures the moments of their lives. Everyone is encouraged to share materials and their stories with one another, perhaps in small groups. The families are encouraged to complete the evaluation together, except for the questions specifically addressed to the children.

Grade Level Appropriateness

Scrapbook Family Night is suitable for all ages.

ORGANIZING SCRAPBOOK FAMILY NIGHT ●

Procedures

1. Use the Planning Guide (see Resource A) to organize Scrapbook Family Night.

2. Make scrapbooks with a variety of colored pages.

3. To begin the Scrapbook Family Night, share a photo album or scrapbook of your own. Explain that we all have great experiences; it is important to remember them, and a scrapbook can help make a record of them.

4. Read aloud from a scrapbook page you have created that tells about a memory or event important to you. Share whatever illustrations, photographs, or keepsakes you included.

5. Show a blank scrapbook and explain that they may finish it during the evening or at home. Encourage the families to discuss their memories before deciding which ones they want to include. Also help them to understand the importance of all of the family members helping in writing and creating the scrapbook pages.

6. Distribute one blank scrapbook per family. Have plenty of supplies at all of the tables so they have access to what they need.

7. Make the atmosphere friendly and casual with soft background music and snacks to munch on as they work.

8. Take a photograph of each family to be included on one of their pages. If you cannot print the photographs that evening digitally or with a Polaroid, let them know you will send them the photos soon so that they can be included in the scrapbooks.

9. Invite the families to share a page with others at their table.

10. Ask each family for a page to photocopy and display in the school.

11. Encourage the families to complete the evaluation form together, except for the questions specifically addressed to the children.

Suggested Agenda

6:30–6:45 Sign in; put on name tags; pick up agenda; eat snacks at tables.

 Snacks: a variety of crackers and/or cut-up fruit

6:45–7:00 Welcome families; give directions for evening; share scrapbook and completed scrapbook page; explain blank scrapbook and materials available; demonstrate putting it together.

7:00–8:00 Families create scrapbooks together. Teacher takes a photograph of and visits with each family.

8:00–8:20 Families share their scrapbooks with others at their table.

8:20–8:30 Say a few closing words and have the families complete the evaluations.

Materials

Invitations

Agendas

Sign-in sheet

Name tags

Camera

Snacks, drinks, and paper products

Evaluation forms

Markers

Crayons

Regular and colored pencils

Pens

Regular and fancy scissors

Glue sticks

Colored paper

Stickers

Cutout shapes

Rubber stamps and stamp pads

Scrapbook pages on different colored paper

Cardstock paper for front and back covers

Tongue depressors

Rubber bands

Tips

- This Family Night could easily be done with one teacher but could also run smoothly with more.
- For students particularly talented in art or writing, this Family Night might be especially appealing. Encourage these and all students to explore alternate forms for making art that they could incorporate into their family scrapbook. Encourage the students to think of creative ways to record their memories.
- Print the pages on a variety of colored paper to make it more interesting.
- Assemble each scrapbook ahead of time and then demonstrate how to take it apart and how to reassemble it. How to bind scrapbook: Photocopy all pages so the layout is with the longest side horizontal (landscape position). Punch two holes with a paper punch on the left side, 5/8 inch from the edge and 2 7/8 inches from the top and bottom. Insert a rubber band from the bottom up through the top, having it stick out enough so that a tongue depressor can be inserted. The stick will lay flat against the top page with the tip of the rubber band, holding it in place. Stretch the other end of the rubber band underneath so that it comes up through the other hole from the bottom page to the top. Insert the other end of the tongue depressor through the rubber band loop.
- Encourage the families to get a drink whenever they would like, so they are not seated the whole time, thus creating a relaxed setting.
- Make sure you spend some time with all students and their families.

For Families Who Cannot Attend Scrapbook Family Night

For families who cannot attend Scrapbook Family Night, send a note home saying you were sorry that they were unable to attend and explain what to do with the blank scrapbook. Include a blank scrapbook so that they can make one at home. Have the students who attended share some of the things they did with their individual pages to help motivate those who did not attend. Encourage the students to make the scrapbook with their families so they will have this treasure of memories to keep forever. Ask them to bring it to school to share with their classmates once it is completed.

RESOURCES ●

Visit local scrapbooking and craft stores for scrapbook page ideas. These stores sell many things that would make the pages more fun and inviting. Use your imagination!

● SCRAPBOOK SUGGESTIONS

Directions for Binding the Scrapbook

The Most Fun We Have Ever Had!

A Family Story We Like to Tell . . .

Birthdays

Funny Times We Have Had

Our Pets

Our Favorite Family Meal

On the Weekends, We Like to . . .

These Are Our Favorite Things . . .

A Trip We Took . . .

One of the most important things in my life is riding+riding tournaments. In my most recent riding tournament I won 2 first place. My friend also got a first place too. But then We had to ride in the same class. I Won, but I told her I Would not have been mad if she had Won.

REPRODUCIBLES ●

For Scrapbook Family Night, we provide a model invitation, a blank agenda form, a blank sign-in sheet (see Resource B), scrapbook pages, and an evaluation form. Add other scrapbook pages you think your students and their families would like.

Come and Make a Family Scrapbook!

Date _____

Dear Family,

You are invited:

What: Scrapbook Family Night

Who: Parents/guardians and children

Date:

Time:

Where:

Why: To create a family scrapbook to record your family memories
 and to get know each other better.

Snacks and drinks will be provided.

Bring photographs and/or other keepsakes of your family that you would
be willing to use to create a scrapbook.

Please return the form below so we will know if you are coming!

YES! My family and I will attend the Scrapbook Family Night on
_____.

_____ _____
(Student's name) (Number of people coming)

Scrapbook Family Night

Welcome Families! Please sign in, put on a name tag, and then follow this agenda for the evening.

When?	What?	Where?	Who?
	Sign in and eat snacks		All
	Welcome and directions		All
	Create scrapbook pages		Families
	Share scrapbooks		Families
	Have closing words and complete evaluation forms		All

How Was Scrapbook Family Night?

What did you like most about the evening?

What will you do with your scrapbook?

What is something you learned about another family?

What suggestions would you make for Family Nights in the future?

How else can we work together to help your child?

For children: What did you learn about a family that you did not already know?

Other comments:

3

Books, Books, and More Books

A Reading-Focused Family Night

WHY DO FAMILY READING NIGHT? ●

Most teachers of elementary students will say that learning to read and improving reading skills are among the most important work that students do in school. Indeed, if students do not read well, every other aspect of schooling suffers. Lack of reading skills usually affects success in life as well. Further, most parents of students ask first about how they can help their children with reading. Many feel eager to help but lack the strategies needed to truly improve the skills of the reader. Many will tell about frustrations they have with a child who is a slow, laborious reader or one who quickly stumbles over words in efforts to "get through" the text without true comprehension.

This workshop, the Family Reading Night, is likely to be one of the most popular for both teachers and families. It was for us. Each of us has conducted more than one Family Night focused on reading. In each Family Night, the majority of time is spent reading great literature. Time can be spent with families learning a reading strategy (or more) together or simply experiencing paired reading. The important thing is to highlight the pleasure and value of book reading.

We suggest beginning reading aloud from a favorite book that will surely make the adults laugh or crave more. This way, the families will be

eager to learn the strategies you are prepared to teach. For Family Reading Night, we provide you with some handy tools such as a handout and bookmarks. The wonderful part of this Family Night is witnessing the children and teens reading alongside their parents or guardians, practicing the strategies.

We encourage you to adapt the Family Reading Night ideas to your students and families. For example, if you teach older readers (fourth to eighth grades), you may want to teach the strategies to your students first and then have them teach their families at the Reading Night. Or, you might want to find ways to have book giveaways at this event. In any case, make Family Reading Night as enjoyable as all of your other Family Nights.

Purpose

The purpose of Family Reading Night is to provide an opportunity for parents and guardians to learn how to better assist their children as they read, using a variety of reading strategies.

Connections to National Standards

Like all of the Family Nights in this book, this one addresses academic standards. The National Council of Teachers of English (NCTE) and the International Reading Association (IRA) standards (2002) included in this Family Reading Night are

Students read a wide range of print and nonprint texts.

Students read a wide range of literature from different periods.

Students apply a wide range of strategies to comprehend, interpret, evaluate, and appreciate texts.

Students develop an understanding of and respect for diversity.

Content of Family Reading Night

In this Family Night, the teacher reads a favorite book to the families in order to set the tone for the evening. Then, the students are separated from the adults for about 45 minutes while the teacher instructs the adults on the 10 simple steps for assisting their children with reading. The teacher demonstrates the strategies and provides tools (bookmarks) to help adults practice them. At this time, the students can be listening to books read aloud, reading themselves, or doing some other book-related activity. The students then come back into the room for the families to practice the strategies together, and the evening ends with the families completing the evaluation form.

Grade Level Appropriateness

Family Reading Night can be adapted for all grade levels. The handout "Ten Ways to Help Your Child During Reading" is designed for primary-grade readers. However, steps 8, 9, and 10 are specifically for

students who are reading independently and can be used with kindergartners through middle-schoolers. The bookmarks are also appropriate for all grade levels. When selecting texts for practice at Family Reading Night, be sure they are of interest to the grade level you are working with. Use magazines, comic books, and other materials that you know inspire reading.

ORGANIZING FAMILY READING NIGHT ●

Procedures

1. Use the Planning Guide (see Resource A) to organize Family Reading Night.

2. To begin the Family Reading Night, start with a favorite read-aloud book that you know the students enjoy. Read the book to the families, allowing for the shared experience of enjoying a good book together.

3. Have many other books on display for the families (about two per student), representing the students' backgrounds and interests. The students will later choose from among these books to practice the strategies with their family members.

4. Separate the adults from the students for approximately 45 minutes. For young children, a teenager or other adult can guide them through more favorite read-alouds, explorations of books in the library, explorations of books on the Internet, or some other book-related activity that is appropriate for the age group. If you choose to do this, be sure the person is experienced or directly teach the person how to read aloud or organize the activities. For older students, activities such as reenacting a scene from a book, making a mural in response to a story, or just reading might be choices you plan for them.

5. Meet with the adults. Using the "Ten Ways to Help Your Child During Reading" guide, lead the families through the reading strategies most appropriate for your students' age group.

6. Select the most appropriate strategies for your students. Demonstrate the strategies, such as "echo reading" and "choral reading, " as if you are the teacher and the adults are the student readers. (Definitions of these strategies are included at the end of this chapter.) Each strategy will need to be demonstrated and explained, as many families do not know teachers' jargon.

7. Give each adult one of each of the bookmarks provided. Then demonstrate the strategies in step 8 using the bookmarks. Finish with steps 9 and 10.

8. Invite the students back into the room so that the families can practice the strategies together. Allow the students to choose the book from the collection you provide.

9. Encourage the families to complete the evaluation forms together, except for the questions specifically addressed to the students.

Suggested Agenda

5:30–5:55 Sign in; put on name tags; pick up agenda; eat.

Dinner: pizza, soft drinks, sliced apples.

5:55–6:05 Welcome, read aloud to the whole group; give directions for the evening; transition to separate rooms for adults and students.

6:05–6:50 For adults: Share the strategies with the adults, demonstrating each one. For children: Have the principal, another teacher, a teen helper, or someone read books or direct an activity for the children during this time. For teens: Plan an activity in response to a book. Be sure the students have a choice in the activity and a choice of book they might respond to.

6:50–7:15 Bring the adults and students together to practice the strategies. Listen and assist as you move from family to family.

7:15–7:30 Complete the evaluation forms and give a few closing words.

Materials

Invitations

Agendas

Sign-in sheet

Name tags

Food, drinks, and paper products

Evaluation forms

"Ten Ways to Help Your Child During Reading" handout

Bookmarks

A variety of books that represent various cultures, genres, and time periods (about two per child)

Tips

- Print the bookmarks on tag board or laminate them so they remain sturdy.
- Three versions of bookmarks are provided, one that focuses on word attack skills, one that focuses on comprehension, and one that encourages the reader.
- Copy the bookmarks onto cardstock, cut out, and laminate.

- For students gifted as readers, be sure there is a selection of books that meets their needs. Encourage the family members of those students to focus on the questions that get the children to compare, analyze, summarize, and synthesize (in general, the latter questions on the book marks). Make sure these students and families know that this Family Reading Night is for them, too.
- If a teacher or principal cannot read to the students while you work with the parents for 45 minutes, another option is to check with the high school for volunteers. Often there will be students who need service hours who would be good at this. Another option is to invite local celebrities to read to the students.
- If you do choose to serve pizza, the average amount to order is usually two pieces of pizza per person. Often young students eat only one piece, and teens and parents usually eat two or three.
- Reinforce the same reading strategies in the classroom that you do during the Family Reading Night to get maximum learning from your students.

For Families Who Cannot Attend Family Reading Night

For families who cannot attend Family Reading Night, send a note home saying you missed them. Then, using the handout of "Ten Ways to Help Your Child During Reading," teach your students what you taught the adults at Family Reading Night. Give the students the bookmarks and handout and encourage them to share with family members at home. Find a time during the school day when all your students can partner with others and practice the strategies. They can take turns acting as teacher/guardian and assisting their partner with reading aloud.

RESOURCES ●

Glossary

Picture Walk—If the book being read has pictures, one good way to begin is to allow the readers to take time to explore the book from beginning to end without reading it. This does not ruin the reading of the book! In contrast, it usually motivates readers to want to read it, and sometimes it builds the necessary background knowledge for reading for comprehension.

Echo Read—This strategy is used if the book is just a little bit too difficult for the reader to read alone. The adult or older reader reads a line, and the child "echoes" the reading of that line. Yes, it does mean that the child's reading is merely "memory-reading," but it is a way for the children to see the words spoken in print. Later, the child can read it a second time without this kind of support.

Choral Read—Like echo reading, this strategy helps the readers get through text that might be just a bit difficult. The adult and child read together aloud some parts of the text, or they can take turns reading together and reading alone. This can be a fun way to read a book together.

● **REPRODUCIBLES**

For Family Reading Night, we provide a model invitation, a blank agenda form, a sign-in sheet (see Resource B), a handout or transparency, bookmarks, and an evaluation form. Feel free to adapt any of these tools to meet your own students' and families' needs.

Come and Listen to Your Child Read!

Date _____

Dear Family,

You are invited:

What: Family Reading Night

Who: Parents/guardians and students

Date:

Time:

Where:

Why: To learn how to help your child with reading and to have fun!

Children will do all the reading!

A light meal and drinks will be provided. You do not need to bring anything.

Please return the form below if you will be there.

YES! My family and I will attend the Reading Family Night on _____.

_____ _____

(Student's name) (Number of people)

Family Reading Night

Welcome Families! Please sign in, put on a name tag, and then follow this agenda for the evening.

When?	What?	Where?	Who?
	Sign in and dinner		All
	Welcome, read aloud, and directions		All
	Reading activity for students		Students
	Strategies for adults		Adults
	Practice reading together		All
	Closing words and evaluation forms		All

Ten Ways to Help Your Child During Reading

1. Let the child hold the book.

2. Encourage a "picture walk" first.

3. Show your interest.

4. Read to the child if he or she cannot read.

5. Have the child "echo read" you.

6. Have the child read chorally with you.

7. Take turns reading pages with harder words.

8. When a child comes to a word he or she does not know, teach the child to:
 Start the sentence over and point to the words.
 Say the first sound.
 Look at the pictures.
 Ask: What would make sense?
 What would sound right?
 Does it look right?
 What would match with the letters I see?
 Skip the word and read to the end of the sentence.
 Look for clues in the next sentence.
 Ask what the word is.

9. Ask your child questions such as:
 Do you like this book? Why or why not?
 Have you read any other books like this one?
 What's your favorite part?
 What does this book make you think of?

10. Deeper-level questions might include:
 What book can you compare this to? Can you compare it to a film or TV show?
 Can you retell the story with all the details?
 Can you summarize the story with only the big ideas?
 What techniques does the author use to get readers to like this book?

11. Make it a pleasurable time!

Book Marks

Help With Words

Look at the vowel sound.
Say every sound in the word.
Does that make sense?
Does that sound like language in
 a book?
Read it again, a bit faster.
Read it again, slower this time.
Look at the picture.
What is a better way to say that
 word?
Try skipping the word for now and
 read to the end of the sentence.
Now go back and check.
Can you make a guess?
Can you cover up part of the word?
Find the little word in the big.
Can you sound it out?
OK, go on and read.

Help With Comprehension

What do you think?
What do you think might happen
next? Why?
What does this remind you of?
 Why?
Can you think of any other
 books/films like this? How
 are they like this one?
What do you like about this book?
 Why?
How might this book be different?
What techniques does the author
 use to make you like this book?

Praise That Teaches

Nice, you read that with
 expression.
Good, you went back and fixed it.
 You knew it didn't make sense.
Rereading helps, doesn't it?
Hmm, good cue.

That's a sophisticated word!

Good strategy.
Smart guess. It makes sense.
You decoded by making every
 sound in the word.
You know a lot of sounds.

Good story, isn't it?

How Was Family Reading Night?

What did you like most about Family Reading Night?

What ideas from Family Reading Night will you most likely use?

For children: When reading with your parent or guardian, what helped you the most?

What suggestions would you make for Family Nights in the future?

How else can we work together to help your child?

Other comments:

4

Meet Our Pets Family Night

● WHY DO MEET OUR PETS FAMILY NIGHT?

Most children either have pets or want pets. Much conversation between elementary students is about their pets. A few of the many concepts students can learn about the animals that are their pets include ecosystems, habitats of animals, and life cycles of animals. Students also can learn practical living skills through discussion about the ownership and care of pets. Elementary students are eager to show their pets to others and tell about their experiences with them.

On Meet Our Pets Family Night, families have the opportunity to bring a pet to school to show and tell what makes their pet special to their family. It is very interesting to see the variety of animals that are kept as pets. Students will learn the unique needs of each animal and learn what is needed for each to thrive. They will learn to describe the individual animal behaviors. Meet Our Pets Family Night also provides an excellent opportunity for families to share, interact, and make new friends.

Some might be concerned about safety issues or just the potential mess of having a Meet Our Pets Family Night, but author Moore has held these events and assures everyone that they can be a great success. She notes,

> We met outside on the bus dock, so everyone lined up along the sidewalk. At one event, we had a dog, cat, fish, ferret, and iguana. When it was their turn, the parent and child showed the pet and told about it. When everyone had shared, people gathered and

talked, with some wanting a closer look at some of the pets. Because it was outside, and the pets were with the parents, we weren't concerned about safety issues. All of the pets were either in a cage or on a leash. Also, since we didn't have food for this event, it could be scheduled right after school if that would work better than at night. Or, it could be scheduled for a Saturday morning. It's a great Family Night to have during a unit on animal study.

Gayle also points out that not all participants need to bring an animal. Some might like to tell about a pet they have had in the past or one that they might be planning to get in the future. They could bring a photograph instead of a live animal. The great thing about this Family Night is how the families learn from each other about the characteristics, idiosyncrasies, and needs of each animal and how it has become an important part of the family.

Purpose

The purpose of this Family Night is to give families the opportunity to share knowledge and experiences about pets they have, or have had, or would like to have.

Connections to National Standards

Like all of the Family Nights in this book, this one addresses academic standards. The National Council of Teachers of Science standards included in this Family Night are

Students learn about the characteristics of organisms.

Students learn about the life cycles of organisms.

Students learn about organisms and environments.

Content of Meet Our Pets Family Night

In this Family Night, each family has the opportunity to bring a pet and talk about its characteristics, idiosyncrasies, and needs. They share whatever information about their pet that they feel would be of interest to the audience. The other students and parents may then ask questions. Books are available for reading, checking out, or possibly buying to take home to read. This collection of books includes a variety of topics such as pet care, animals that make good pets, and animal habitats, just to name a few. The teacher leads a closing discussion on the similarities in the care of the pets. The evening ends with the families completing the evaluation form together.

Grade Level Appropriateness

Meet Our Pets Family Night is suitable for all ages.

● ORGANIZING MEET OUR PETS FAMILY NIGHT

Procedures

1. Use the Planning Guide (see Resource A) to organize Meet Our Pets Family Night.

2. To begin Meet Our Pets Family Night, have books about pet care and animals on display for browsing, checking out, and/or buying. Perhaps a pet-store owner would set up a display of "How to" books that could be purchased. Or, you could display a collection of such books from the library.

3. Have snacks such as popcorn, pretzels, nuts, and drinks on a table (optional).

4. Take a picture of each family with its pet.

5. Introduce the plan for the evening, and then call on the first family to share.

6. After all have shared, lead a summary discussion on the similarities of care each pet needs.

7. Complete evaluation forms.

8. Provide more time to browse the books, look at each other's pets, and talk with each other if desired.

Suggested Agenda

6:15–6:30 Sign in; put on name tags; pick up agenda; browse the book display; eat snacks and talk; take a picture of each family and its pet.

6:30–6:35 Welcome; explain the purpose of the workshop; give directions for the evening; introduce the first speaker.

6:35–7:45 Families speak about their pets.

7:45–8:00 Have summary discussion, closing words, and complete the evaluation forms.

Materials

Invitations

Agendas

Sign-in sheet

Name tags

Camera

Snacks, drinks, and paper products

Paper towels, plastic bags, and spray cleaner in case of pet accidents

Books

Evaluation forms

Tips

- This workshop may need to be outside, so season and weather would be a consideration.
- Do a study of animals that would make good pets before Meet Our Pets Family Night.
- It would be difficult to include a meal at this Family Night because of the animals present.
- Suggest that families bring their pets in cages or on leashes.
- Encourage students and families to share a variety of animals.
- Use the pictures of each family and its pet for a bulletin board display in the classroom or the hall at school, and then send them home.
- Family members need to decide who will speak about their pet before sharing. Preferably the student will be the one who shares.
- More than 12 speakers might make the evening too long. Each speaker should be limited to 5 minutes. If more than 12 want to share, perhaps there could be two groups for sharing time.
- A good follow-up math activity in the classroom would be to make a graph showing the various kinds of animals that attended the Family Night.

For Families Who Cannot Attend Meet Our Pets Family Night

For families who cannot attend Meet Our Pets Family Night, send a note home saying you missed them. Invite them to come by the school to see the pictures on the bulletin board of the families who did attend with their pets. In a group discussion let the students who attended share some of the things they learned that night with the students who were not there. Encourage the students who could not attend to make a five-minute presentation to the class about their pet using photographs or other visuals.

REPRODUCIBLES ●

For Meet Our Pets Family Night, we provide a model invitation, a blank agenda form, a blank sign-in sheet (see Resource B), a suggested form to guide the family member in speaking about the pet, and an evaluation form. Feel free to adapt any of these tools to meet your own students' and families' needs.

Come Share Your Pet!

Date_____

Dear Family,

You are invited:

 What: Meet Our Pets Family Night

 Who: Parents/guardians and children

 Date:

 Time:

 Where:

 Why: To share your pet with the class and their families and/or to learn about the pets of other students in the class.

Snacks will be provided. You do not need to bring anything except your pet or a photograph of one.

Please return the form below if you will be there.

--

YES! My family and I will attend the Meet Our Pets Family Night on _____.

_____ _____
(Student's name) (Number of people)

We (WILL or WILL NOT) be bringing our pet and sharing. (Circle Will or Will not)

Our pet is a _____.

_____We do not have a pet to bring but would like to share an experience about a pet we have had or hope to have.

Guidelines for Sharing Your Pet

"Our pet's name is _____. He/she is a _____.

He/she is _____months/years old. We have had him/her for
_____months/years."

Describe your pet.

Tell about what kind of care it needs (food, water, cage, yard, etc.).

Tell who takes care if it.

Tell why it is a good family pet; or maybe NOT a good family pet!

Tell something funny or unique about your pet.

Meet Our Pets Family Night

Welcome Families!

Please sign in, put on a name tag, get acquainted with other families and their pets, and get a snack.

When?	What?	Where?	Who?
	Book browsing and picture taking		All
	Welcome and directions for sharing		All
	Sharing about pets		All
	Summary discussion, closing words, and evaluation		All

How Was Meet Our Pets Family Night?

What did you like most about the Meet Our Pets Family Night?

What was something new you learned about animals?

For children: Which animal would you like to have for a pet? Why?

What suggestions would you make for Family Nights in the future?

How else can we work together to help your child?

Other comments:

5

A Morning of Family Fun With Math

● **WHY DO FAMILY MATH MORNING?**

Mathematics is everywhere. We use it every day—when we park our car, double a recipe, do a puzzle, give a tip, or estimate how long it will take to do the tasks we have planned for the day. Math is essential in so many parts of our lives, and those who can do mathematics with ease are at an advantage. But many see mathematics as scary, uninteresting, or outside their own needs. Mathematics has the reputation for being hard and that it takes a special talent to be good at it. But, those students who make it into advanced mathematics classes are not necessarily smarter or more talented. They are usually more experienced and confident though. Experience and confidence in mathematics must begin early. Children need to see math in their everyday world and be encouraged to think through something mathematical, solve problems, and worry less about correct answers; they need to focus instead on the thinking involved in the process of using mathematics. Small but frequent successes in "doing math" can go a long way toward building children's confidence and a desire to work through mathematical puzzles and problems.

This Family Event will be a fun way to get families involved in mathematics through games. The first game is designed for young children, and the fifth game is designed for older children. The three games in between can be adapted for any age group. Emphasize that winning is not the important part—thinking is. If you can, make extra copies of the game formats for the families to take home and play again or adapt them to invent their own games.

While none of us has conducted a Family Math Morning (or Night) quite like this one, authors Moore and Kyle have held a Math Family Night that included asking the families to bring in a favorite family dish for a potluck dinner. They encouraged involving the children in preparing the food as a way to experience mathematics in everyday life. After the Family Night, they used the recipes to create mathematical word problems that the children worked on in the classroom. Each family received a recipe book as a reminder of the many opportunities at home to work on mathematics with their children.

Purpose

The purpose of this Family Event is to learn more about mathematics through games and provide enjoyable tools for further practice at home.

Connections to National Standards

Like all of the Family Nights in this book, this one addresses academic standards. The National Council of Teachers of Mathematics (NCTM) standards included in this Family Event are

Estimation Activity: Understand how to measure using nonstandard and standard units (grades K–2)

Estimation Activity: Develop and use strategies to estimate the results of whole-number computations and to judge the reasonableness of such results (grades 3–5)

Estimation Activity: Develop strategies for estimating the perimeters, areas, and volumes of irregular shapes (grades 3–5)

Estimation Activity: Use a variety of methods and tools for computations, including objects, mental computation, estimation, paper and pencil, and calculators (grades 6–8)

Estimation Activity: Use common benchmarks to select appropriate methods for estimating measurements (grades 6–8)

Game 1: Develop a sense of whole numbers and represent and use them in flexible ways, including relating, composing, and decomposing them (grades K–2)

Game 2: Count with understanding and recognize "how many" in sets of objects, using multiple models to develop initial understandings of place value and the base-10 number system (grades K–2)

Games 3 and 4: Understand the effects of adding and subtracting whole numbers (grades K–2)

Games 3 and 4: Develop fluency in adding, subtracting, multiplying, and dividing whole numbers (grades K–8)

Game 5: Investigate, describe, and reason about the results of subdividing, combining, and transforming shapes (grades 3–5)

Game 5: Develop fluency in operations with real numbers, using mental computations or paper-and-pencil calculations for simple cases and technology for the more complicated cases (grades 6–8)

CONTENT OF FAMILY MATH MORNING

As the families arrive they will eat breakfast and fill out estimation forms as they estimate the number of animal crackers in the different-sized jars that are on display. Then the families will move into small groups and the teacher will explain the math games they will play. Next, they will play the games of their choice. The teacher will be there for any needed assistance. After playing the games, the families will be told the actual numbers of animal crackers in each jar. The teacher can also explain a few strategies for better estimating numbers like that. Those who come closest to the actual number of animal crackers in each jar will take that jar home. Encourage the families to complete the evaluation forms together, except for the questions specifically addressed to the children. Distribute packets containing all of the games as the families leave.

Grade Level Appropriateness

The math games provided here are varied in grade level appropriateness. The first is primarily for young children, and the last is primarily for older children. The three in the middle can be adapted for all ages and mathematical abilities, including the gifted in math.

ORGANIZING FAMILY MATH MORNING

Procedures

1. Use the Planning Guide (see Resource A) to organize Family Math Morning.

2. To begin Family Math Morning, have various-sized jars of animal crackers on tables with estimation forms, pens, and pencils. Invite the families to estimate the number of crackers in each of the jars and record their estimations.

3. When all are seated and have estimated, explain to the families the games they will be invited to choose to play. Briefly demonstrate how each game is played.

4. Tell the families where each game will be located (in different parts of the room or, if possible, in different rooms).

5. Provide time for the families to participate in at least two games. In each room or corner of the room, provide written directions for the game. Tell them how much time they will have to play before switching to a new game.

6. Walk around to each game and assist or observe each family.

7. Reconvene everyone in the general area to share insights from the games.

8. Then, divulge the number of crackers in each of the jars. Give the jars to the families with the best estimates for each.

9. Ask the winners to explain how they arrived at their estimates. If the families do not explain specific strategies, two are provided.

10. Have the families fill out the evaluation forms.

Suggested Agenda

10:00–10:20 Sign in; put on name tags; pick up agenda; estimate; eat.

Breakfast: Cereal selections, milk, coffee, and juice.

10:20–10:30 Welcome; give directions for the morning; explain directions for playing games; make transition to game areas.

10:30–11:30 Play games.

11:30–12:00 Reconvene to the large room; divulge numbers in each jar; give winners jars to take home; share strategies for estimation; complete evaluation forms; distribute packets of all games.

Materials

Invitations

Agendas

Sign-in sheet

Name tags

Food, drinks, and paper products

Evaluation forms

Multiple sets of math games

Playing cards

Paper

Pencils

Scissors

Old newspapers or magazines

About six different-sized see-through jars

Animal crackers

Estimation forms

Toothpicks (17 per family)

Tips

- After the estimation strategies are shared, you might want to have a new jar for estimating, so that the families can try out the newly learned strategies.
- You might have more estimation jars containing things other than animal crackers, so more people will be able to "win."
- You might read aloud a math book or allow the families to read them. Some book suggestions are provided in the Resources section.

For Families Who Cannot Attend Family Math Morning

For families who cannot attend Family Math Morning, send a note home saying that you missed them. Then, send home with the child a packet of the games to keep and play at home.

● RESOURCES

Children's Books With Mathematics Themes

Archambault, J. (1989). *Counting sheep*. New York: Trumpet Club.

Burns, M. (1994). *The greedy triangle*. New York: Scholastic.

Crews, D. (1968). *Ten black dots*. New York: Scholastic.

Daniels, T. (2001). *Math man*. New York: Scholastic.

Duke, K. (1998). *One guinea pig is not enough*. New York: Dutton Children's Books.

Hirschmann, K. (2002). *Necco sweethearts math magic*. New York: Scholastic.

Hoban, T. (1988). *Twenty-six letters and ninety-nine cents*. New York: Scholastic.

Hutchins, P. (1986). *The doorbell rang*. New York: Scholastic.

Leedy, L. (1997). *Measuring penny*. New York: Scholastic.

Leedy, L. (1995). *Two times two equals boo!: A set of spooky multiplication stories*. New York: Holiday House.

Leedy, L. (1994). *Fraction action*. New York: Holiday House.

Leedy, L. (1992) *The monster money book*. New York: Scholastic.

Losi, C. (1997). *The five hundred twelve ants on Sullivan Street*. New York: Scholastic.

McGrath, B. (1998). *More M&M's math*. Watertown, MA: Charlesbridge.

Merriam, E., & Murphy, S. (1996). *Ready, set, hop!* New York: Scholastic, E. (1993). *Twelve ways to get to eleven*. New York: Trumpet Club.

Murphy, S. (1997). *Betcha!* New York: Scholastic.

Murphy, S. (1997). *Divide and ride*. New York: Scholastic.

Murphy, S. (1997). *Elevator magic*. New York: Scholastic.

Murphy, S. (1996). *Get up and go!* New York: Scholastic.

Neuschwaner, C. (1997). *Sir Cumference and the first round table*. New York: Scholastic.

Pallotta, J. (2002). *Hershey's Milk Chocolate weights and measures.* New York: Scholastic.

Pallotta, J. (1999). *Hershey's Milk Chocolate fractions book.* New York: Scholastic.

Stamper, J. (1998). *Tic-tac-toe three in a row.* New York: Scholastic.

Tang, G. (2001). *The grapes of math.* New York: Scholastic.

Walsh, E. (1991). *Mouse count.* New York: Trumpet Club.

Walton, R. (1996). *How many how many how many.* Cambridge, MA: Candlewick Press.

REPRODUCIBLES ●

For Family Math Morning, we provide a model invitation, a blank agenda form, a sign-in sheet (see Resource B), forms and explanations for the estimation activity, five different games with directions and materials, and an evaluation form. Feel free to adapt any of these tools to meet your own students' and families' needs.

Come and Play Some Games to Learn Some Math!

Date_____

Dear Family,

You are invited:

 What: Family Math Morning

 Who: Parents/guardians and children

 Date:

 Time:

 Where:

 Why: To learn some great math games to play at school and home!
 Cereal, milk, coffee, and juice will be served.

Bring your entire family.

Please return the form below if you will be able to come.

--

YES! My family and I will attend the Family Math Morning on _____.

_____ _____

(Student's name) (Number of people)

Family Math Morning

Welcome Families! Please sign in, put on a name tag, and then follow this agenda for the morning.

When?	What?	Where?	Who?
	Sign in, breakfast, and estimation		All
	Welcome, demonstration or games, and directions		All
	Game time		Families
	Sharing time		All
	Estimation activity revisited		All
	Closing words and evaluation forms		All

Estimating Strategies

1. When looking at a jar of animal crackers, first try to count how many are on the bottom layer of the jar. Then try to count how many layers there might be in the jar. Multiply those numbers. Ask yourself, "Is this a good estimate?"

2. When looking at a jar of animal crackers, first look at the palm of your hand, curved as if to hold water. Try to imagine what ten crackers would look like in that space (how much space they would take up). Now look back at the jar. How many of those handfuls could be in the jar? Go ahead and touch the jar with your hand as you estimate. Don't forget that a pile or more might fit in the middle of the jar! Multiply the number of your handfuls by ten. Think, "Would that be a wise estimate?"

Sample Estimation Form

Jar #___1___ My estimate is 35	Jar #___2___ My estimate is 175	Jar #___3___ My estimate is 300	Jar #___4___ My estimate is 650	Jar #___5___ My estimate is 1,260
Name *Ashley* 36	**Name** *Jack* 102	**Name** *Emma* 292	**Name** *Gael* 421	**Name** *Ting* 995
Jar #_____ My estimate is	Jar #_____ My estimate is	Jar #_____ My estimate is	Jar #_____ My estimate is	Jar #_____ My estimate is
Name_____	Name_____	Name_____	Name_____	Name_____

Estimation Form

Jar #_____ My estimate is _____ Name_____	Jar #_____ My estimate is _____ Name_____	Jar #_____ My estimate is _____ Name_____	Jar #_____ My estimate is _____ Name_____	Jar #_____ My estimate is _____ Name_____
Jar #_____ My estimate is _____ Name_____	Jar #_____ My estimate is _____ Name_____	Jar #_____ My estimate is _____ Name_____	Jar #_____ My estimate is _____ Name_____	Jar #_____ My estimate is _____ Name_____
Jar #_____ My estimate is _____ Name_____	Jar #_____ My estimate is _____ Name_____	Jar #_____ My estimate is _____ Name_____	Jar #_____ My estimate is _____ Name_____	Jar #_____ My estimate is _____ Name_____
Jar #_____ My estimate is _____ Name_____	Jar #_____ My estimate is _____ Name_____	Jar #_____ My estimate is _____ Name_____	Jar #_____ My estimate is _____ Name_____	Jar #_____ My estimate is _____ Name_____

Game 1: Finding Math

Materials:

Directions

Old newspapers and magazines

Directions:

Using newspapers and magazines, have each family find each of the following:

A time

A date

A child's age (who is playing the game)

An adult's age (who is playing the game)

A number greater than 1,000

A number greater than 100,000

A number that represents the temperature

A page number over 40

A price

A graph

The first family to find all items and says "Math-o!" wins!

Game 2: Place Value Cards

Materials:

 Number cards

 Paper and pencil

 Directions

Directions:

1. One person in the group removes three cards from the pile and lays them face up for all to see.

2. Each family or individual writes three three-digit numbers using those cards.

3. Each family or individual orders the numbers from least to greatest.

4. The first family or individual to write the numbers down in order from least to greatest wins.

5. Play five times to see who wins overall.

For young children, this can be played with two-digit numbers. For older children, this can be played with four-, five-, and six-digit numbers.

Example:

4 6 7

 467

 674

 764

Number Cards for Game 2

1	2	3
4	5	6
7	8	9

Game 3: Adding Cards

Materials:

Deck of playing cards with face cards removed

Paper and pencil

Directions:

1. One adult or child draws three cards and lays them face up for all to see.

2. Each person adds the numbers and the first to say the sum aloud gets a point.

3. Shuffle the cards and play 10 times to see who gets the most points.

Younger children can draw two cards. Older children can multiply the three numbers. Have the winners explain their processes.

Game 4: The Name Game

Materials:

Letter–number chart
Paper
Pencil

Directions:

1. Make a poster or distribute a handout of the letter–number chart.

2. One person in the group introduces him- or herself with first names and spelling. Someone writes the name for all to see.

3. The members of the team use the letter–number chart to add numbers that correspond with the letters in the person's name.

4. The first person to call out the sum wins.

5. Play 10 times to see who has the highest total.

Example:

Juanita = 4 + 1 + 1 + 2 + 1 + 2 + 1 = 12

Older children can multiply the numbers or square the total.
If the families know each other very well, use middle names.

Letter–Number Chart—Game 4

A 1	B 2	C 3	D 3	F 4	G 3
H 2	I 1	J 4	K 3	L 2	M 3
N 2	O 1	P 3	Q 10	R 2	S 2
T 2	U 1	V 5	W 5	X 6	Y 6
Z 7	A 1	E 1	I 1	O 1	U 1

Game 5: Square Puzzle

Materials:

Toothpicks

Directions:

1. Provide each family with 17 toothpicks. Have them duplicate the square puzzle picture as shown below.

2. Remove five toothpicks to form three perfect squares.

3. Emphasize that this game is not a race and that experimenting is part of the learning process.

4. If someone solves the puzzle that morning, recommend that the strategy used be kept a secret so the other families can continue to puzzle over their game at home.

This game is very difficult for many, but older and younger children can try!

Square Puzzle

How Was Family Math Morning?

What games did your family like?

For children: Which games will you most want to play again?

What suggestions would you make for Family Events in the future?

How else can we work together to help your child?

Other comments:

6

Sharing Family Stories and Traditions Night

WHY DO FAMILY STORIES AND TRADITIONS NIGHT? ●

Students are more motivated in classrooms in which a sense of community is of importance. When students know that the teacher truly cares and wants to build a relationship of trust, respect, and genuine concern, it helps them to become comfortable and more willing to take risks among their peers.

This Family Stories and Traditions Night is one that helps teachers to really get to know their students and their families, which, in turn, is very valuable in creating a caring classroom and helping to guide instruction. This Family Night involves sharing favorite family foods, stories, and traditions. The wonderful part of this Family Night is the building of community among those who attend as they share who they are. This Family Night might be one you choose to do first, in an effort to get to know the families and allow them a comfortable way to participate.

Author Moore worked with her student teacher and other student teachers in their school as they planned and put on a Family Stories and Traditions Night. The student teachers developed activities for teachers of all grades to use during the week before the event to generate interest. The students interviewed their families about family origins and traditions and brought in family artifacts to share. On the night of the event, a huge wall map was covered with push pins locating the many places the families had "come from."

We encourage you to adapt the Family Stories and Traditions Night to your students and families. Be sure to celebrate each family's uniqueness and delight in building and strengthening relationships among all of the families.

Purpose

The purpose of Family Stories and Traditions Night is to learn about and respect similarities and differences across families. A second purpose it to provide an opportunity for families to build graphing and map skills together.

Connections to National Standards

Like all of the Family Nights in this book, this one addresses academic standards. The National Council of Teachers of English (NCTE), the International Reading Association (IRA) standards (2002), and the National Council for Teaching Mathematics (NCTM) standards included in this family night are

Students develop an understanding of and respect for diversity.

Students use spoken, written, and visual language to accomplish their own purposes.

Students create and use representations (e.g., graphs) to organize, record, and communicate mathematical ideas.

Content of Family Stories and Traditions Night

In this Family Night, families gather to eat home-cooked food, share stories and traditions, and participate in graphing and writing activities. The teacher invites families to participate by asking them to share (informally) a family story or tradition. In addition, the teacher asks the families to bring a favorite dish. As the families arrive, they mark a world map hanging on the wall showing their family origin. They eat the potluck dinner family style around tables with tablecloths. Then, the teacher leads the group in a graphing activity with information provided by the families when they first arrived, such as countries of origin or the different food groups represented at the potluck. Then, in groups of three or four families, one member (can be a student) reads one of Patricia Polacco's books (see the Resources section at the end of this chapter). Then, each family works together to draw a family portrait and writes the text of a family story or tradition that is meaningful to them.

Grade Level Appropriateness

Family Stories and Traditions Night is suitable for all grade levels because we all have family stories and traditions. Adapt the graphing activity to meet the grade level appropriateness. For younger students, a simple bar graph would be suitable, while older students will enjoy the challenge of learning how to display the data in a variety of graphing ways.

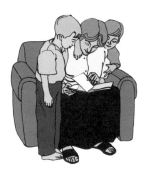

ORGANIZING FAMILY STORIES ● AND TRADITIONS NIGHT

Procedures

1. Use the Planning Guide (see Resource A) to organize Family Stories and Traditions Night.

2. This Family Night works well with one class or with more.

3. Make your own family portrait and write your family tradition to use as a model for the evening.

4. Have the families show their family's origin on a world map (posted for all to see and easily reached) as they arrive.

5. Help organize the food that the families bring into groupings so that all salads, side dishes, meats, and desserts are grouped together.

6. Once most have arrived, have the families serve themselves and enjoy the potluck dinner with one another.

7. Encourage the families to read the "story cards" on the tables and share their own family's stories.

8. Once all have finished the meal, make a more formal, whole-group welcome.

9. Explain the plans for the rest of the evening. Show the group some of the books written by Patricia Polacco and tell them they include many of her personal family stories and traditions. Show her family's origins on the map (Ireland and Russia).

10. Conduct a graphing lesson with the family information gathered from the map or meal.

11. Share your family portrait and read the text of your family tradition to help them understand their task for the evening.

12. Separate the whole group into smaller groups of three to four families each. Ask one member from each group to pick a book written by Patricia Polacco and read it to their small group. (If the book is very long, it is okay to read only part of it.)

13. Ask individuals to verbally share one of their family's traditions within their small group.

14. Invite the families to work together to draw a family portrait (on the frame provided) and write the text of their family story or tradition.

15. Invite the families to share with their small groups, if they would like.

16. Encourage the families to complete the evaluation forms together, except for the questions specifically addressed to the children.

Suggested Agenda

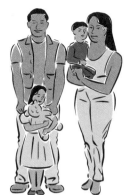

5:30–6:15 Sign in; put on name tags; mark family's origins on the map; pick up agenda; eat.

Enjoy the potluck dinner. While eating, read the "story cards" on the tables; share family stories with others.

6:15–6:40 Welcome; give directions for evening; conduct graphing lesson with family information; make transition to small group areas.

6:40–7:30 Read a Patricia Polacco book; share family traditions or stories; draw family portraits; write family stories or traditions; share portraits.

7:30–7:40 Have closing words and complete evaluation forms.

Materials

Invitations

Agendas

Sign-in sheet

Name tags

Camera

World map

State map

City map

Yarn

Pushpins

Labels

Tablecloths

Food (brought by families and teachers), drinks, and paper products

Ice (cooler)

Table decorations

Story cards

Chart paper and/or overhead projector for graphing activity

Variety of books written by Patricia Polacco

Lined paper

Pens and pencils

Template for frames

Markers

Crayons

Colored pencils

Evaluation forms

Tips

- This workshop may best be conducted later in the school year when some trust has been built between the families and teachers, because families are being asked to share stories and food.
- You may want to coordinate efforts so you don't have 20 desserts; or, take your chances and make a meal with whatever comes!
- Print the story cards on card stock or laminate them so they remain sturdy.
- Conduct a Patricia Polacco author study before this Family Night to familiarize the students with her books.
- Have the students make decorations for the tables.
- Continue to reinforce graphing skills in the classroom by graphing the different continents on the world map, the cities or counties of the state, the different dishes brought to the potluck, and/or of different family members.
- Take a photograph of each family to use as a thank you note, or to include in the portrait gallery or in a class book.
- Display the family portraits in the "Family Portrait Gallery" in your school.
- Bind the stories and traditions into a class book.
- Prior to the Family Night, discuss with the students the proper etiquette while dining with others.
- Have the students make place cards for the tables.
- Have small groups determined ahead of time.
- Give frames previously made by the students.

For Families Who Cannot Attend Family Stories and Traditions Night

For families who cannot attend Family Stories and Traditions Night, send a note home saying that you missed them and tell them about the evening. Tell them you would like their family portrait to be included in the "Family Portrait Gallery" at school and encourage them to draw their family inside the frame you have sent home. Ask them to write about a family story or tradition on the lined paper you have also sent. To help encourage those who did not attend to complete these activities at home, have the other students verbally share the story or tradition they wrote about during the Family Night.

RESOURCES ●

Books by Patricia Polacco:

Oh look. New York: Philomel Books, 2004.

G is for goat. New York: Philomel Books, 2003.

The butterfly. New York: Philomel Books, 2000.

Mrs. Mack. New York: Philomel Books, 1998.

In Enzo's splendid garden. New York: Penguin Putnam, 1997.

Aunt Chip and the great Triple Creek Dam affair. New York: Philomel Books, 1996.

Babushka's Mother Goose. New York: Penguin Putnam, 1995.

My ol' man. New York: Penguin Putnam, 1995.

My rotten red headed older brother. New York: Simon & Schuster, 1994.

Pink and Say. New York: Philomel Books, 1994.

The bee tree. New York: Putnam, 1993.

Chicken Sunday. New York: Philomel Books, 1992.

Mrs. Katz and Tush. New York: Dell, 1992.

Picnic at Mudsock Meadow. New York: Putnam, 1992.

Just plain fancy. New York: Dell, 1990.

Thundercake. New York: Philomel Books, 1990.

The keeping quilt. New York: Simon & Schuster, 1988.

Rechenka's eggs. New York: Philomel Books, 1988.

● REPRODUCIBLES

For Family Stories and Traditions Night, we provide a model invitation, a blank agenda form, a blank sign-in sheet (see Resource B), story cards, and an evaluation form. Feel free to adapt any of these tools to meet your own students' and families' needs.

Come and Share Stories and Traditions With Your Child!

Date _____

Dear Family,

You are invited:

 What: Family Stories and Traditions Night

 Who: Parents/guardians and children

 Date:

 Time:

 Where:

 Why: To enjoy a nice meal with friends and to share and learn of our many family stories and traditions.

Bring a favorite family dish for our dinner. Drinks will be provided.

Please return the form below if you will be there.

--

YES! My family and I will attend the Family Stories and Traditions Night on_____.

_____ _____

(Student's name) (Number of people)

Family Stories and Traditions Night

Welcome Families! Please sign in, put on a name tag, and then follow this agenda for the evening.

When?	What?	Where?	Who?
	Sign in, mark family's origins on map, eat and share stories using story cards		All
	Welcome and directions		All
	Graphing activity		All
	Read book, share traditions and stories, write tradition or story and share		Families
	Closing words and evaluation forms		All

Family Stories and Traditions

With your family members, talk about a favorite family story and a favorite family tradition. Decide together on one of each to write down on the paper provided. You will probably come up with many good ideas, but if you need some suggestions, take a look at the story cards for other ideas that might work for your family.

Story Cards

Tell about something that was difficult to do.	Tell about a friend of yours.	Tell about something that you think is funny.	Tell a story about one of your relatives.
Tell about what you like to do in your free time.	Tell about your favorite season.	Tell about one of your teachers.	Tell about one of your vacations.
Tell about a pet.	Tell about your best birthday.	Tell about a time when you were proud of yourself.	Tell about a time in which you were surprised.
Tell about things you are frightened of.	Tell about what your family likes to eat.	Tell about a famous person you would like to meet.	Tell about what you like to do on the weekends.

How Was Family Stories and Traditions Night?

What did you like most about the Family Night?

What is something you learned about another family?

For children: What was your favorite part of the Family Night? Why?

What suggestions would you make for Family Nights in the future?

How else can we work together to help your child?

Other comments:

7

Game-Making/Writing Family Night for Developing Writing Skills

WHY DO GAME-MAKING/WRITING ● FAMILY NIGHT?

Only in the last 20 years or so has writing taken so many forms for so many different purposes in our society. Being skilled as a writer today can mean many different things. Some people are good story writers while others' strengths are in offering opinions on the Internet. Some people can write memos, advertisements, or editorials that can change people's minds, while others write songs or prayers to change people's minds. Some people, like journalists, like to write to report on the world; others want to reflect on the world through personal writing; and still others blend fiction and nonfiction, such as in film, and actually create the world through their writing. Each different genre calls for very different skills, and children should be encouraged to write in as many genres as possible from the time they are very young.

This Family Night is not designed to teach writing; that is to be done in and out of school over a long period of time with much opportunity to

write, receive feedback, and rewrite. This Family Night is to bring families together to play a bingo-like game that will encourage children (or families) to write in a variety of different genres over the next month or so. The game can be laminated and re-created over time, if families choose. You may want to use something similar in the classroom to help the children stretch their writing skills while still providing the necessary choice for maintaining an interest in writing.

Two of us (McIntyre and Kyle) worked with over 100 families in a large urban school with many different languages spoken by families. Yet, through careful demonstration of how to make this game that encourages at-home writing, all were successful. We conducted our event similarly to the steps outlined here, except that we made it both a Reading and Writing Night. We found that it was important to come with a list of possible writing tasks, as some families do not consider writing (or reading) to be anything more than school-like tasks. We wanted them to see the writing and reading they do at home as worthwhile as well.

We encourage you to adapt the Game-Making/Writing Family Night to meet the needs of your families. For very young children, writing includes drawing and much listing. For older children (fourth through eighth grades), writing should definitely include media. It is important, though, that teachers be sensitive to differences in access to technology. It is also important to keep the choice of writing to the children. In any case, be sure that the Game-Making/Writing Family Night is enjoyable and risk-free.

Purpose

The purpose of this workshop is to have families create a bingo game that provides opportunities for home writing activities.

Connections to National Standards

Like all of the Family Nights in this book, this one addresses academic standards. The National Council of Teachers of English (NCTE) and the International Reading Association (IRA) standards (2002) included in this Family Night are

Students adjust their use of spoken, written, and visual language (e.g., conventions, style, vocabulary) to communicate effectively with a variety of audiences and for different purposes.

Students apply knowledge of language structure, language conventions (e.g., spelling and punctuation), media techniques, figurative language, and genre to create, critique, and discuss print and nonprint texts.

Students use a variety of technological and information resources (e.g., libraries, databases, computer networks, video) to gather and synthesize information and to create and communicate knowledge.

Students use spoken, written, and visual language to accomplish their own purposes.

Content of Game-Making/Writing Family Night

In this workshop, teachers provide the forms and ideas for making a writing bingo game that families can play at home. To make the game board, teachers distribute ideas and encourage the children and their families to select or create writing tasks that are age appropriate and of interest to the child. Teachers give suggestions on how parents might play the game with their child. For instance, the child might draw from an envelope one marker designating which task from the board he or she will do. The child completes the writing tasks until all are done. The families will need to create their own celebration system to use as they complete a "row" or "cover all." For example, when the child completes a row or column, they might receive a healthy treat, or, when the child completes all activities ("cover all"), a prize like a trip to the library or bookstore is awarded. Even better is when families gather to hear one of the texts read aloud after a row or cover all is completed. The idea is to help families value the many different writing genres and provide opportunities for children to participate in them at home. Encourage the families to complete the evaluation forms together, except for the questions specifically addressed to the child.

Grade Level Appropriateness

Game-Making/Writing Family Night can be adapted for all grade levels. For very young children, the tasks can be similar to those for older children, but the actual product will look different. For example, a story might be done mostly in pictures with just a few words. Encourage the families to praise the children's efforts and recognize that writing does not have to be "correct" in order for it to be well done. Older children can and should be using technology of some sort for the selected writing tasks.

ORGANIZING GAME-MAKING/ WRITING FAMILY NIGHT ●

Procedures

1. Use the Planning Guide (see Resource A) to organize Game-Making/ Writing Family Night.

2. To begin Game-Making/Writing Family Night, start with a variety of writing samples from your students that illustrate many kinds of genre. For instance, read aloud samples of your students' work that illustrate a variety of text forms. You might read aloud a list, a request, a personal note sent between students, a diagram, a poem, a story, a letter, an Internet blog entry, an e-mail message, a reflection on what was learned in school, a mathematics problem written by a student, an essay, a book on spiders, a graph or chart of the heights of the children in the class, a response to a story, an analysis of a piece of art, a joke, a riddle, a game, or a comic strip. The idea is to share with the families that each kind of writing is important for

different reasons and that each kind of writing takes a different set of skills. Encourage the parents and guardians to value all sorts of writing the children do.

3. Explain the bingo game and how it works.

4. Demonstrate how to create the game using an overhead projector.

5. Emphasize that the students and adults should select the writing tasks together, and they should be those that the children *want* to do.

6. Give plenty of time for game-making (35 minutes).

7. Encourage the families to complete the evaluation forms together, except for the questions specifically addressed to the children.

Suggested Agenda

5:00–5:25 Sign in; put on name tags; pick up agenda; eat.

Meal: Homemade submarine sandwiches, baked chips, milk, oatmeal cookies.

5:25–5:55 Welcome families; share writing samples, give directions for game-making.

5:55–6:30 Families create bingo game together.

6:30–6:45 Have closing words and complete evaluation forms.

Materials

Invitations

Agendas

Sign-in sheet

Name tags

Food, drinks, and paper products

Writing samples to share

Evaluation forms

List of possible writing tasks

Bingo game form

Marker form

Pens and pencils

One 8½ × 11 inch envelope per family to put game in

Tips

- Communicate that choice is important for writing, and the children should get to choose which activities go on the board. Communicate

that constructing meaning and expression is more important than correctness.

- Tell the families that it is okay if they do not finish the game that evening, and that they can take materials home to finish, if necessary.
- Provide a folder for the children to collect all their writing samples to share later in school. Some of the pieces might be good for their school portfolio, if they have one.
- Make other kinds of game boards for different purposes, such as reading, practicing an instrument, or doing chores around the house (see the suggested activities for a mathematics game).
- Provide wheat bread and low-fat meats as options for the sandwiches.

For Families Who Cannot Attend Game-Making/Writing Family Night

For the families who cannot attend Game-Making/Writing Family Night, send a note home saying that you missed them. Then, provide a copy of a completed game for the families to use as an example (which you will request back) and materials so they can make their own games. Explain to the children the purpose and procedures for making the game, and encourage the children to bring the game in when finished so you can see what they have done with it.

REPRODUCIBLES ●

For Game-Making/Writing Family Night, we provide a model invitation, a sign-in sheet (see Resource B), a blank agenda form, possible writing tasks, the game form, the marker form, a sample game for families to see, an evaluation form, and possible math game activities. Feel free to adapt any of these tools to meet your own students' and families' needs. Importantly, communicate that choice is important in writing and expression is more important than correctness.

Come and Think Up Fun Writing Activities Together!

Date _____

Dear Families,

You are invited:

What: Game-Making/Writing Family Night

Who: Parents/guardians and children

Date:

Time:

Where:

Why: To create a bingo game with writing activities for your child
to play at home.

A light meal will be provided. No need to bring anything!

Please return the form below if you will be there.

--

YES! My family and I will attend the Game-Making/Writing Family Night
on _____.

_____ _____

(Student's name) (Number of people)

Game-Making/Writing Family Night

Welcome families! Please sign in, put on a name tag, and then follow this agenda for the evening.

When?	What?	Where?	Who?
	Sign in and eat		All
	Welcome, sharing of writing samples, directions for game making		All
	Game-making time		Families
	Closing words and evaluation forms		All

Possible Writing Tasks

Write a poem and hang it up
Write a letter and send it to a:
 Friend
 Sibling
 Parent
 Relative
 Teacher
 Principal
 Congressperson
 President
 Preacher, rabbi, or other spiritual leader
 Next year's class
Write an e-mail to any of the above
Find an Internet blog site you like and participate
Participate in an Internet chat room
Write the directions for this game
Make holiday cards and send them
Write lists! Make them of:
 Friends
 Relatives
 TV shows
 Books
 Vegetables
 Fruits
 Animals
 Grocery items
 Wishes
Write labels for where things belong in the house
Write a prayer to say at mealtime or bedtime
Write a thank-you note
Write a tongue twister
Write a comic strip
Write a song (can be adapted from a well-known tune)
Write a recipe for:
 A favorite sandwich
 A favorite ice-cream sundae
 A happy family
 How to be successful in school
Write a list for a scavenger hunt
Write clues to a treasure hunt
Write an advertisement for your school
Write an advertisement for your favorite (TV show, movie, book, etc.)
Write a script involving at least three people about one situation
Write a schedule for an upcoming family event
Create a catalog of something you love

Writing Bingo!

1	2	3	4
W			
R			
I			
T			
E			

Sample Finished Game

Writing Bingo!

1	2	3	4
Write a letter to a relative **W**	Write a grocery list	Write an advertisement for your school	Write a skit or a one-scene play from a book you like
Write a list of favorite books **R**	Don't write, read something!	Write a list of goals for yourself (for this month, this year, or your whole life)	Write a song about yourself to the tune of "I've Been Working on the Railroad"
Write a tongue twister **I**	Go to an Internet chat room and write to new friends	Write the directions for this game	Write a schedule for yourself for getting your chores and other tasks done
Write an e-mail to someone **T**	Write a recipe for your favorite sandwich	Write a recipe for a happy family	Write a note to your teacher describing what he/she does well

Marker Form

W 1	W 2	W 3	W 4
R 1	R 2	R 3	R 4
I 1	I 2	I 3	I 4
T 1	T 2	T 3	T 4
E 1	E 2	E 3	E 4

How Was Game-Making/Writing Family Night?

What did you like most about this Family Night?

How often do you plan to use the bingo game?

For children: Which tasks on your game board are you looking forward to doing?

What suggestions would you make for Family Nights in the future?

How else can we work together to help your child?

Other comments:

Adapt for Any Topic

Example: Mathematics

Measure the length of five things in your home

Measure the perimeter (length + width × 2) of your front door

Measure the area (length × width) of your refrigerator

Measure the volume (length × width × depth) of your refrigerator

Measure the diameter of a plate

Figure out the radius of a CD

Add all the whole numbers from 1 to 100

Count the number of:

 Doors in your house

 Light bulbs

 Windows

 Chairs

 Buttons on five shirts

 Forks

 Pictures on the walls

Record the number of minutes the TV is on

Add the ages of family members

Figure out in months the difference in age of all family members

Measure ingredients for a recipe

Record the temperature for a week

Measure the area of several rooms in your house

Count someone's change

Add the bills in someone's wallet or purse

Figure the cost of five things advertised in the newspaper or a catalog

Divide the number of crackers or cookies in a box by the number of family members

Multiply the cost of a candy bar by 7, 30, 365

Figure out the number of calories you eat in a meal

Estimate the number of:

 Raisins in a box and then count them

 Cans in your cabinet or pantry and then count them

 Chair legs in your household and then count them

 Books in your house and then count them

8

Pajama Party Family Night

A Reading Event

● **WHY DO PAJAMA PARTY FAMILY NIGHT?**

Reading is the most important skill we teach. Because it is so essential, we want children to associate reading with warm, happy times. What is better than the bedtime story? Also, because reading is not *reading* unless comprehension is taking place, it is important that students learn comprehension strategies so that they understand what they read.

The Pajama Party Family Night is not only fun, but it will also help students and families to learn ways of responding to books through writing so that deeper comprehension occurs. In this workshop, families will attend three sessions in which they will learn different ways of responding to books in writing. The families will be invited to come in their pajamas if they so desire and will be invited to enjoy some hot chocolate and treats as they are "snuggling up to their books." Hopefully this will help to illustrate and encourage families to continue "snuggling up with books" at home.

Author Miller has had several Pajama Party Family Nights at her school. Sometimes she does it with her class alone, but often she teams up with a few other teachers to make it like one giant pajama party. She assures parents that wearing pajamas is optional. Some parents prefer to come in with a robe over their clothes, but many parents have come complete with pajamas, slippers, and night cap. In October of 2004, the teachers centered the event around the book *Polar Express* and used the event to

kick off a reading challenge set by the National Education Association. The evening began with the whole group watching the DVD version of the book. Then, the families got into smaller groups and rotated through four activities: (1) learning a few reading strategies; (2) practicing the strategies or just perusing books set out for them; (3) snacking on hot chocolate and cookies; and, finally, (4) having their pictures taken in front of a *Polar Express* train. The evening was very successful. It can also be surprising what the students love most. When reading the evaluations, Miller expected the families to comment on viewing the DVD of the book, learning new strategies, or having hot chocolate. But one student said that his favorite part of the evening was when "Mrs. Miller read *No, David!*" as part of her lesson.

We encourage you to adapt the Pajama Party Family Night to an event or book that you and your class are interested in. We encourage you to adapt the type or format of the written responses to reflect those used and taught in your classroom. You might want to find ways to have giveaways at this event that might include hot chocolate, mugs, slippers, or books. In any case, make Pajama Party Family Night fun, like the others.

Purpose

The purpose of Pajama Party Family Night is to provide an opportunity for students, parents, and guardians to learn how to better comprehend as they read, using a variety of written responses.

Connections to National Standards

Like all of the Family Nights in this book, this one addresses academic standards. The National Council of Teachers of English (NCTE) and the International Reading Association (IRA) standards (2002) included in this Family Night are

Students read a wide range of print and nonprint texts.

Students apply a wide range of strategies to comprehend, interpret, valuate, and appreciate texts.

In addition, depending on what the families read, the following might also be addressed:

Students develop an understanding of and respect for diversity.

Students read a wide range of literature from many periods.

Content of Pajama Party Family Night

This Family Night is designed for multiple teachers to do together, although one teacher could do it alone. One of the teachers (dressed in pajamas if desired) reads a favorite book to the families in order to set the tone for the evening. The book might be one that goes along with the pajama theme or could be one that might include families reading together. The teacher then briefly discusses and explains that comprehension can be

increased through written responses. She will explain that they will have the opportunity to learn and practice some of these writing responses throughout three sessions of their choice (if several teachers are participating). Families will then move to the locations of three 25-minute sessions in which instruction, reading, and writing will take place. Each teacher will demonstrate and model a few different written responses to each of the three groups that come to their room throughout the evening. If you are the only teacher, you will want to demonstrate and model many if not all of the responses. After the modeling, the families will read a book or magazine article of their choice and practice the written responses in their "response journal," which will be given to them during the first session. The families will choose a total of three sessions to attend, if several teachers participate. The evening will end with the completion of the evaluation forms and some closing words.

Grade Level Appropriateness

Pajama Party Family Night can be adapted for all grade levels by selecting texts that are appropriate to their reading abilities, are varied, and meet their many interests.

● ORGANIZING PAJAMA PARTY FAMILY NIGHT

Procedures

1. Use the Planning Guide (see Resource A) to organize Pajama Party Family Night.

2. This Family Night works well with several teachers but could be done alone.

3. Assemble the reading response journals by copying the outside cover (on the right half-side of an 8 ½ × 11 inch page) and inside cover (on the back, left half-side of an 8 ½ × 11 inch page) on cardstock paper. Fold the paper in half, and add about five sheets of blank paper (folded in the middle) to the inside of the cardstock cover. Staple on the outside fold to form a booklet.

4. Decide which written responses each teacher will demonstrate, so that families will have the opportunity to learn a wide variety of written responses.

5. Make your own example of a written response to the book you are using as a read-aloud to use as a model.

6. To begin the Pajama Party Family Night, start with a favorite read-aloud that you know the students enjoy. Read the book to the families, allowing for the shared experience of enjoying a good book together.

7. Show the families a reading response journal and discuss how written responses help one's comprehension. Share your example.

Explain that they will receive a response journal in their first session.

8. Explain the location and procedures of rotating through three sessions (if several teachers participate). Encourage the families to stay together through the evening.

9. In each individual session, the teacher explains a few of the written responses. She explains how they are done and models a "think-aloud" of how one might be done (an example of a "think-aloud" is provided at the end of this chapter). Then have the families choose a text they would like to read from a variety of books and magazines. After reading their text, they are to complete their written response, modeled after other responses they have heard, in their response journal.

10. Have hot chocolate and treats in the individual rooms to help create a cozy atmosphere.

11. Have the families attend two other sessions that inform them of different kinds of written responses.

12. Invite the families to return to the larger room where the evening began for closing words.

13. If you are planning on any giveaways, conduct those within the large group.

14. Encourage the families to complete the evaluation forms together, except for the questions specifically addressed to the children.

Suggested Agenda

6:30–6:40 Sign in; put on name tags; pick up agenda.

6:40–7:00 Welcome families; read aloud to the whole group; give directions for the evening; transition to separate rooms for the first session.

7:00–7:25 First session.

7:25–7:50 Second session.

7:50–8:15 Third session.

8:15–8:30 Have closing words; present the giveaways; and complete the evaluation forms.

Materials

Invitations

Agendas

Sign-in sheet

Name tags

Food, drinks, and paper products

Evaluation forms

Magazines

Book collection including fiction and nonfiction

Response journals

Schedule and map of workshop rooms or areas

Pens and pencils

Crayons or colored pencils

Tips

- Encourage young children to bring a favorite stuffed animal or blanket to read with.
- Encourage the families to continue using their response journals when they read at home.
- Ask the parents to send in and share their journal at a later date.
- Make hot chocolate early and keep it in crock pots.
- Copy entries from the response journals to display in the hall.
- Decorate the invitation with origami pajamas made by the children.
- Make the invitation in the shape of a mug to go with the hot chocolate that will be served.
- Make time for the families to share with each other in small groups at the end of each session.
- Make a basket filled with hot chocolate, marshmallows, mugs, and a book or books to be given away.

For Families Who Cannot Attend Pajama Party Family Night

For families who cannot attend Pajama Party Family Night, send home a note attached to a packet of hot chocolate saying that you missed them. Send home a response journal and explain the procedures for the written responses. Encourage your students to share with their families and to try writing responses at home.

● RESOURCES

A Term You Might Need to Know

A "think-aloud" is when you illustrate your thinking during a demonstration. For example, if a teacher demonstrates how to write a paragraph, he might begin to write on an overhead projector for all to see and say aloud what is in his mind as he writes. It might sound like, "Hmm . . . How should I begin? I want to interest my readers. So, I'll start with a question. 'Do you know who the greatest basketball coach ever was?' (The teacher writes.) "No, I'd better change that to, 'Who is considered the greatest basketball coach of all time?' That way the readers can't argue with me

about the answer." (The teacher continues talking aloud as he writes, rereads what he has written, revises, edits, and compliments or complains about his own text. The idea is to show the process of writing in all of its messiness.)

REPRODUCIBLES ●

For Pajama Party Family Night, we provide a model invitation, a blank agenda form, a blank sign-in sheet (see Resource B), response journal ideas, and an evaluation form. Feel free to adapt any of these tools to meet your own students' and families' needs.

SAMPLE READER RESPONSE ●

Recently I read a book called Nancy Drew and the Case of the Stolen Bears. I liked this book because it had spying in it, and that it had so much action in it. For example, Nancy falling through ice. Nancy fell through ice at the ice skating party. She was trying to find out who was calling for help. She got too close to the thin ice, and she fell through the ice.

What I didn't like was the author used chuckle to much. Why din't the author use laugh are giggle?

By: Elena Meeks

Come to a Pajama Party!

Date _____

Dear Family,

You are invited:

> What: Pajama Party Family Night
>
> Who: Parents/guardians and children
>
> Date:
>
> Time:
>
> Where:
>
> Why: To snuggle up with some great books.
> Children will do all the reading!

Hot chocolate and treats will be provided.

If you like, wear your comfy pajamas and bring a favorite stuffed animal or blanket.
Bring the entire family!

Please return the form below if you will be there.

YES! My family and I will attend the Pajama Party Family Night on _____.

_____ _____

(Student's name) (Number of people)

Pajama Party Family Night

Welcome Families!

Please sign in, put on a name tag, and then follow this agenda for the evening.

When?	What?	Where?	Who?
	Sign in		Families
	Welcome, read-aloud, and directions		All
	First session		All
	Second session		All
	Third session		All
	Closing words and evaluation forms		All

_____*'s Reading Response Journal*

Written Responses

While reading alone or with someone:

I wonder . . . Write things you wonder about before you read, during your reading, and after you have finished reading.	In the News Write a headline and article about your book. Write it as it would appear in a newspaper or magazine.
Predictions Predict what you think will happen before you read the story. Write other predictions as you are reading. After you have finished reading, write about how your predictions compared to what actually happened.	Write a Letter Write a letter telling someone about the book you read or the facts that you learned. Or write to a character in the story.
Connections Write the connections you think of while reading. Think of connections between the book and things you already know, personal experiences, and with other books you have read, or with movies you have seen.	Book Rating Rate your book like movies are rated. 1 star = not great 2 stars = OK 3 stars = pretty good 4 stars = so good I couldn't put it down. Discuss your rating in your journal.
Visualizations Stop at various times as you are reading to draw some pictures that show what you are picturing in your mind.	Summary Write five sentences or less that summarize the most important parts of the text. Make a small sketch illustrating one part.
The Most Important Words After reading, select three to five words that are important to the meaning of the story. Be selective. Write why they are important.	Drawings Each person draws and/or writes about the story. Discuss your writings and drawings. Then, respond to your partner by writing or drawing. Finally, discuss again.

How Was Pajama Party Family Night?

What did you think about this evening?

What ideas from this Family Night will you most likely use?

What suggestions would you make for Family Nights in the future?

How else can we work together to help your child?

For children: When reading and writing responses with your parent or guardian, what helped you the most?

Other comments:

9

Meeting Famous People Through Biographies Family Night

● **WHY DO FAMOUS PEOPLE FAMILY NIGHT?**

Children are often intrigued by the lives of famous people, both in history and present day. Learning about what makes a person famous can teach children about cultural trends, issues, and events. Many times they also learn about important life skills such as bravery, perseverance, and compassion. Children also are typically exposed to fiction from the beginning of their early reading experiences more than they are to nonfiction. This is why it is so important that we consciously provide opportunities to read nonfiction such as biographies.

Most parents of students want to know how they can help their children with reading. Many are eager to help but lack the strategies that truly improve the skills of the reader. This Famous People Family Night will help families to learn and practice strategies for reading biographies and other nonfiction texts. They will learn to identify important information about the life of the famous person as they read. They will stop and think about the text in order to identify the most important information. This builds their reading comprehension.

Finally, students will also gain experience in speaking before a small audience as they share the biography that they read with their families.

Learning to present thoughts is a valuable skill, and it can be learned at an early age.

We encourage you to adapt the Famous People Family Night to your students' interests and to what has been taught in the classroom. You might devote this night specifically to a study of famous authors, presidents, athletes, or scientists, depending on the curriculum area you want to emphasize.

Purpose

The purpose of this Family Night is for families to learn strategies for reading biographies and how to share a book with a small group. In this process families become acquainted with the lives of people who have made a difference.

Connections to National Standards

Like all of the Family Nights in this book, this one addresses academic standards. The National Council of Teachers of English (NCTE), the International Reading Association (IRA) (2002), and the National Council of Social Studies (NCSS) standards included in this Family Night are

Students read a wide range of print and nonprint texts.

Students read a wide range of literature from many periods.

Students apply a wide range of strategies to comprehend, interpret, evaluate, and appreciate texts.

Students study time, continuity, and change.

Students study people, places, and environments.

Students develop an understanding of and respect for diversity.

Content of Famous People Family Night

In this Family Night the teacher provides many kinds of biographies, including children's picture biographies, that represent a diversity of race and gender. The whole group will see the teacher model a strategy for reading biographies or other nonfiction material. Then the teacher will suggest ways for sharing the book with others. The families will choose a book, find a secluded area, read the book, and decide how they want to share the book. Then, in small groups of two or three families, each family will share their famous person. The evening ends with the families completing the evaluation form together.

Grade Level Appropriateness

Famous People Family Night can be adapted to all grade levels. The reading level of the books available for the evening would need to fit the grade and reading levels of the students.

● ORGANIZING FAMOUS PEOPLE FAMILY NIGHT

Procedures

1. Use the Planning Guide (see Resource A) to organize Famous People Family Night.

2. To begin Famous People Family Night, demonstrate the strategy for reading a biography.

3. Demonstrate one way to share a book with others.

4. Explain the procedures for the next activities of the evening.

5. The families choose their books.

6. Each family finds a secluded spot in which to work.

7. The families read their book, and then plan and practice a way to share their book with others.

8. The teacher circulates among the groups to remind them when sharing will begin.

9. The families reconvene and organize themselves into small groups of two or three families each.

10. Within these small groups, each family shares the famous person they read about.

11. When the groups are finished sharing, the teacher distributes the evaluation forms for each family to fill out.

12. The teacher makes closing remarks to end the evening.

Suggested Agenda

6:15–6:40 Sign in; put on name tag; pick up agenda; eat; move to designated area.

Dinner: Varied kinds of sandwiches, pretzels, apples, and drinks

6:40–7:00 Welcome; model the strategy for reading biographies; give directions for the evening; make transition to rooms.

7:00–7:30 Families select a biography and read it together, using the demonstrated strategy.

7:30–7:45 Prepare to share.

7:45–8:00 Share in groups.

8:00–8:15 Have closing words and complete the evaluation forms.

Materials

Invitations

Agendas

Sign-in sheet

Name tags

Handouts on strategies for reading and sharing books about famous people

Food, drinks, and paper products

Evaluation forms

Many biographies on the appropriate reading levels for the students

Sticky notes

Drawing paper and pencils

Tips

- Plan this workshop in a space large enough for the families to spread out or go to other rooms to read their books without being disturbed by others.
- Circulate as the families read.
- Invite a local famous person in the community to share about the importance of education.
- Seek out the newer biographies on current famous people.

For Families Who Cannot Attend Famous People Family Night

For families who cannot attend Famous People Family Night, send a note home saying that you missed them. Send home a copy of the handout "Strategies for Reading Biographies" and "Ideas for How to Share a Book." Spend some time in class sharing these ideas, so the children who were not able to attend can learn them. You may want to have your students check out a biography from your classroom collection or school library. Encourage the families to read biographies about famous people with their children.

REPRODUCIBLES ●

For Famous People Family Night, we provide a model invitation, a blank agenda form, a blank sign-in sheet (see Resource B), a handout, and an evaluation form. Feel free to adapt any of these tools to meet your own students' and families' needs.

Come and Learn About Famous People!

Date _____

Dear Family,

You are invited:

 What: Famous People Family Night

 Who: Parents/guardians and children

 Date:

 Time:

 Where:

 Why: To read about the lives of people who have made a difference

Children or adults may choose to read.

Food and drinks will be provided. You do not need to bring anything.

Please return the form below if you will be there.

--

Yes! My family will attend the Famous People Family Night on _____

_____ _____

(Student's name) (Number of people)

Famous People Family Night

Welcome Families! Please sign in, put on a name tag, eat, and then move to the designated area. Follow this agenda for the evening.

When?	What?	Where?	Who?
	Sign in and dinner		All
	Welcome, modeling, directions, transition		All
	Families reading		Families
	Families preparing to share		Families
	Families sharing in small groups		Families
	Closing words and evaluation forms		All

How Was Famous People Family Night?

What did you like most about this Family Night?

What interesting facts did you learn about someone?

For children: Who else would you like to read about? Why?

What suggestions would you make for Family Nights in the future?

How else can we work together to help your child?

Other comments:

Strategy for Reading Biographies

Get a set of sticky notes in assorted colors.

Read short sections (a paragraph to a few pages, depending on the age of the child) of the book. Stop and ask, "What did I learn from that section?" Use a sticky note to mark a section, sentence, or word that is particularly interesting, important, or new to you.

Review the three marked passages.

Reread and discuss (or think about) what you marked with the sticky notes.

Ideas for How to Share a Book

Share the three parts of the book you marked with sticky notes as most important, interesting, or new.

Read a short section from the book aloud.

Dramatize a part of the book.

Choose a few important words from the book and explain why they are important to the book.

Sketch an image you have after reading the book and explain your sketch.

Tell about a connection you made while reading the book.

10

Sharing Hobbies, Talents, and Interests Family Night

● **WHY DO HOBBIES, TALENTS, AND INTERESTS FAMILY NIGHT?**

In an effort to promote a feeling of community within the families of the class, teachers need to provide ways for them to get to know each other better. Students are more motivated in classrooms where a sense of community is important. Students learn so much from each other and are eager to share what they know. This Family Night provides an opportunity for the families to learn about and from others. Giving the parents the opportunity to shine as experts lets them know their knowledge and expertise are valued.

This Hobbies, Talents, and Interests Family Night will be a lot of fun. Family members can choose to share a particular area of expertise, collection, hobby, or interest in a 10-minute (or longer, depending on how many families present) discussion or demonstration with the rest of the families. This could be something related to their work, a lifelong activity, or a new area of interest. We have found that some families need to be encouraged to volunteer, as they might not view themselves as experts until teachers

point it out. They may need a little nudge from you to volunteer to participate. Some people do not like to "brag" about being an expert in an area, while others welcome the opportunity.

Authors Kyle and Moore held a Hobbies, Talents, and Interests Family Night and scheduled it for later in the year, after the families had experienced several other Family Nights and seemed comfortable with one another. Some of the families shared hobbies such as golf and their collections of iron skillets, Beanie Babies, masks, and model cars; one father shared his talent in art by bringing his portfolio; and others shared work-related information about such things as lawn and tree care and EMS equipment. Moore found that "Many of the families made connections they might not have otherwise. And, it was great to see the children sharing right along with the adults. They obviously are learning a great deal outside of school."

We encourage you to adapt the Hobbies, Talents, and Interests Family Night to meet the needs of your families. You may have discovered that many families have interesting hobbies, or unusual professions, or lots of talent. If so, you may want to limit the evening to sharing only one of these areas.

Purpose

The purpose of Hobbies, Talents, and Interests Family Night is for families to share their expertise so they and the teacher can get to know each other better and extend learning in the classroom.

Connections to National Standards

Like all of the Family Nights in this book, this one addresses academic standards. The National Council of Social Studies (2002) standards included in this Family Night are

Students will develop an understanding of people, places, and environments.

Students will develop an understanding of individual development and identity.

Students will (possibly) develop an understanding of production, distribution, and consumption.

Students will (possibly) develop an understanding of civic ideals and practices.

Students will develop an understanding of and respect for diversity.

Content of Hobbies, Talents, and Interests Family Night

In this Hobbies, Talents, and Interests Family Night, the teacher invites families to share their expertise on a hobby, talent, or interest in a short discussion or demonstration. After the family has agreed to participate, the teacher arranges a space for them to set up materials they might want to

use for their presentation. Each participant is assigned an area (may be a table) to display their materials for their demonstration. If their presentation needs to be done outside, the teacher may need to have "outside presentations" and "inside presentations." As each family shares, the audience listens and then asks questions. The teacher encourages the presenters to allow a few minutes for a question and answer session after each short presentation. When all have finished sharing, the teacher thanks everyone for coming and sharing and then distributes the evaluation forms. The evening ends with the families completing the evaluation forms together.

Grade Level Appropriateness

Hobbies, Talents, and Interests Family Night is suitable for all ages. Parents will know how to make their presentation appropriate for the age group because the audience is the same age as their child.

● ORGANIZING HOBBIES, TALENTS, AND INTERESTS FAMILY NIGHT

Procedures

1. Use the Planning Guide (see Resource A) to organize Hobbies, Talents, and Interests Family Night.

2. Contact those who have volunteered to share to determine what assistance you can give them in planning their presentations. Assure them that they need not plan extensively and that the sharing will be informal.

3. When the families arrive, show them where they can put materials they will be using in their presentations.

4. As they arrive, invite them to sign in, put on name tags, and serve themselves and enjoy the meal with one another.

5. When all have finished their meal, make a more formal, whole group welcome. Explain the procedure for the rest of the evening.

6. You may want to share your own hobby, talent, or interest first.

7. Introduce the first speaker and proceed with each family.

8. Outside groups may need to share first; then the group can move inside for the others so that the audience is in a more confined area at the end of the evening.

9. Take a photograph of each family as they are sharing.

10. You may want to schedule this evening for later in the year, after the families have attended other Family Nights and know you and the other families better.

Suggested Agenda

5:30–5:45 Sign in; put on name tags; pick up agenda; set up for demonstration.

5:45–6:15 Eat dinner.

Hot dogs, pickles, carrot sticks, drinks, and fruit

6:15–7:45 Welcome families; give directions; have families share.

7:45–8:00 Closing words and complete evaluation forms.

Materials

Invitations to share at the workshop

Invitations to attend the workshop

Agendas

Sign-in sheet

Name tags

Camera

Food, drinks, and paper products

Evaluation forms

Pencils

Items families may need to set up their materials, such as tape, push pins, and staples

Tips

- A follow-up phone call will probably be necessary to encourage some families to volunteer to share. Some will feel shy while others will not realize they are experts on a topic until you point it out. So, the written invitation might require additional encouragement. We suggest that, after extending the written invitation to all families, you target a few families you know who have interesting collections, hobbies, interests, skills, or professions to ask them personally to share. Assure them that they need not plan extensively, that you will help them in any way, and that the sharing will be informal.
- For those who do respond to the initial invitation, you will need to phone them to ask what assistance you can give in planning the presentation.
- You might want to share your own area of expertise with your students before sending the initial invitation, so they understand that "expertise" can be informal and not school-related.
- Encourage *any* family member to share.
- A hot dog meal is a good one to have outside, picnic style.
- If you choose to do hot dogs, a crock pot makes this meal quick and easy.

- After Hobbies, Talents, and Interests Family Night, have the students write thank you notes to the family presenters.
- Collect materials and books that are related to the topics presented to have available in your classroom so that students can extend their learning.
- Photograph each presenter so the pictures may be used for a classroom or hall bulletin board, newsletter, class book, or be sent to the family with a thank you note.
- Plan no more than 10 presentations in one session; more would make the evening too long.

For Families Who Cannot Attend
Hobbies, Talents, and Interests Family Night

For families who cannot attend Hobbies, Talents, and Interests Family Night, send a note home saying you missed them and tell them about the evening. Invite them to come by the classroom if you have pictures displayed. Invite students who were not able to attend to share in the classroom the following day. If another Family Night is to be planned, encourage families to attend the next one.

● REPRODUCIBLES

For Hobbies, Talents, and Interests Family Night we provide a model invitation to share, a model invitation to attend, a blank agenda form, a sign-in sheet (see Resource B), and an evaluation form. Feel free to adapt any of these tools to meet your own students' and families' needs.

Come Share Your Hobby, Talent, or Interest!

Date _____

Dear Family,

We are planning a Hobbies, Talents, and Interests Family Night in which we would like you to share your collections, skills, hobbies, interests, or professions. Do you have an interesting collection of something that others might enjoy seeing or hearing about? Do you have a particular skill (golf, knitting, crafts, etc.) that others might admire? Do you have a hobby you might share? What work do you do that might interest your child's classmates and their families? Please consider sharing your collection, skill, hobby, interest, or profession at this event to be held _____ (date) at _____ (place).

We hope that families will share their expertise in a 10-minute (or less) talk or demonstration. It will help to have something to show. This will be very informal. Save a little time for questions when you are finished sharing. If any member of your family, or perhaps the whole family, would be willing to share, please fill out the form below and return it with your child.

Sincerely,

--

YES! I would like to share something at the Hobbies, Talents, and Interests Family Night.

I will share ————————————————————————

My name is ———————————————— and I am a family member of

———————————— (Student's name) My phone number is ——————————.

Come to Hobbies, Talents, and Interests Family Night!

Date _____

Dear Family,

You are invited:

What: Hobbies, Talents, and Interests Family Night

Who: Parents/guardians and children

Date:

Time:

Where:

Why: To learn more about the families of the students in your child's class.

We will have a light picnic meal of hot dogs, pickles, carrot sticks, fruit, and drinks.

Please return the form below if you can come.

--

YES! My family will attend the Hobbies, Talents, and Interests Family Night on _____.

_____ _____

(Student's name) (Number of people)

Hobbies, Talents, and Interests Family Night

Welcome Families! Please sign in, put on a name tag, and then follow this agenda for the evening. If you are sharing, find your assigned space and set up.

When?	What?	Where?	Who?
	Sign in, set up for your demonstration		All
	Eat dinner		All
	Welcome and directions for the evening		All
	Families sharing outside		All
	Families sharing inside		All
	Closing words and evaluation forms		All

How Was Hobbies, Talents, and Interests Family Night?

What did you like most about the evening?

What topics at this Family Night were of most interest to you?

For children: What did you learn tonight that you would like to know more about? Why?

What suggestions would you make for Family Nights in the future?

How else can we work together to help your child?

Other comments:

11

Poetry Family Morning

WHY DO POETRY FAMILY MORNING? ●

Why are so many adults afraid of poetry? Why do children love to hear it? These questions provide the reasons for doing Poetry Family Mornings. First, many adults fear or dislike poetry because of their negative experiences with it in school. Many were taught they had to interpret poems they could not understand in the way some scholar or teacher interpreted them. There was only one right answer, and it was not theirs. Some had to memorize poems they did not understand or had to write them without being taught *how* to write them. These experiences may have led to the dislike of poetry and school learning in general.

Yet children love to hear poetry. From nursery rhymes as preschoolers, to Shel Silverstein's humorous poetry, to the warmth and love of Eloise Greenfield's poems, to downright scary poems such as those by Jack Prelutsky, children love the thrill of beautiful language combined with meaningful images. When children are exposed to a lot of poetry, they begin to appreciate and even cherish the classic poets like Emily Dickinson, Robert Frost, and Langston Hughes and today's famous poets like Billy Collins and Lucille Clifton. Eventually their own writing improves as they borrow techniques from these great writers.

This Family Event will focus on helping families appreciate poetry together. It can also (if you want to take it this far) be a chance to have families write poems in a risk-free way, after being taught explicitly a few things about how poetry works. Two of us (McIntyre and Kyle) conducted Poetry Family Morning for more than 100 families in a large urban school near our university, and it was a huge success. Ellen McIntyre taught the

children and families the exact lessons on the attributes of poetry provided in the reproducibles. However, instead of using exclusively the classical poetry included here, she also used examples from modern-day poets such as Billy Collins, Gwendolyn Brooks, and Quincy Troupe to address the interests and cultural backgrounds of the families represented. She also read a lot of funny, moving, and silly poems aloud in order to get the families warmed up. After the lesson, the parents and children worked together to write poems. We were stunned by the quality of the products and the willingness of the families to read them aloud. We provided construction paper for mounting the poems, and we made a gallery of poems on one of the hallways in the school building. The gallery stayed there for over a month, and both parents and children were proud to see their work displayed.

We also suggest beginning the morning by having copies of short poems on the tables the families can be reading while they are waiting for the Poetry Family Morning to begin. Then, we suggest you read aloud some of the best children's poems you can find, poems that the whole family can enjoy. (A list of some of our favorite poetry books and anthologies is included at the end of this chapter.) You then can help families understand poetry by sharing the information we provide here, or even more sophisticated instruction, if you are particularly talented in this area. Finally, for those who want to, we encourage you to assist families with writing their own. For those who do, it is delightful to hang them on the school wall for visitors to read.

We encourage you to adapt the Poetry Family Morning to meet the needs of your families. For very young children, you might include nursery rhymes; for older children (fourth to eighth grades), you should share a mix of poetry, including some that are written for the young and some written for older readers. When read aloud, listeners come to appreciate the poem at whatever developmental level they happen to be with regard to poetry. In any case, be sure Poetry Family Morning is enjoyable and risk-free.

Purpose

The purpose of Poetry Family Morning is to experience poetry together in a warm, risk-free way. It can also be a chance for families to create a new poem together.

Connections to National Standards

Like all the Family Nights in this book, this one addresses academic standards. The National Council of Teachers of English (NCTE) and the International Reading Association (IRA) standards (2002) included in this Family Night are

> Students read a wide variety of literature from many periods in many genres to build an understanding of the many dimensions.

> Students employ a wide range of strategies as they write and use different writing process elements appropriately to communicate with different audiences for a variety of purposes.

Content of Poetry Family Morning

For this Family Event, teachers read a variety of poetry to families, including those in which the families can join in for choral reading. Then the teachers instruct the families on the attributes of poetry, including a few examples. Teachers and families can discuss the attributes and which lines of the poems they prefer. The families then have an opportunity to write a poem together to share (or not) with others. For those who choose not to write, they can read more poetry together and select a favorite to share during sharing time.

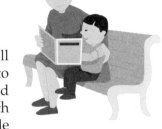

Grade Level Appropriateness

Poetry Family Morning can be adapted for all grade levels. For very young children, be sure to include nursery rhymes. Older children can and should be exposed to some classical poetry, such as the examples we have included in the sample lessons. When selecting poems for Poetry Family Morning, be sure they are of interest to the grade level you are working with.

ORGANIZING POETRY MORNING ●

Procedures

1. Use the Planning Guide (see Resource A) to organize Poetry Family Morning.

2. To begin Poetry Family Morning, start by reading aloud some favorite poems. Usually funny poems such as those by Shel Silverstein or some of those by Jack Prelutsky can create a fun atmosphere.

3. Read a few poems in which families can join in on the choral reading of certain parts. You may want to have those sections on an overhead for the families to read from.

4. Read some poems that are meant for both children and adults, such as those by Langston Hughes or Robert Louis Stevenson.

5. After much reading and enjoyment of poetry, conduct a short "mini-lesson" about poetry, focusing on what makes a poem a poem.

6. Provide families with paper and other writing materials, so that they can attempt a short poem of their own. Those who choose not to write can select from books provided and read poetry to one another.

7. This next part is very important. If you have families write, they *must* have an opportunity to share what they have written with others. On the other hand, it must be *very* clear that sharing is optional! To share, we recommend that families share their poems in small groups (pairs or groups of three families) to lessen the risk. Then, if some are comfortable, they can share them with the whole group. For families who choose not to write, they can select a favorite poem they read that morning to share with the others.

8. Provide construction paper and other decorating items so the families can mat their poems to be hung on the school wall for all to read.

9. Encourage the families to complete the evaluation forms together, except for questions that are specifically addressed to the children.

Suggested Agenda

9:00-9:15	Sign in; put on name tags; pick up agenda; eat.
	Breakfast: Muffins or bagels, juice, bananas, and coffee
9:15-9:45	Welcome families; give directions for morning; share a variety of poems.
9:45-10:00	Discuss the samples by asking, "What makes this poetry? Which one do you like? Why?"
10:00-10:30	Families write a poem together (optional), or they can read poems instead from the collection of books.
10:30-10:45	Families share their written poems in small groups.
10:45-11:00	Give closing words and complete evaluation forms.

Materials

Invitations

Agendas

Sign-in sheet

Name tags

Food, drinks, and paper products

Evaluation forms

Overhead projector

Overhead transparencies

Sample poems (that represent the families in attendance) copied for the tables and read-alouds

Books of poetry for those who want to read instead of write

Transparency of "Characteristics of Poetry"

Construction paper, a variety of colors

White paper

Pens and pencils (fun, colored and gel pens, if you have them)

Various markers and crayons

Tips

- Be sure that at least some of the poetry you read aloud represents the families in attendance. By this we mean to share poems about and by people with experiences that match the families in race, geography, and background experiences.

- Practice reading the poems aloud before Poetry Family Morning so that your delivery is meaningful to the listeners. (Reading poems aloud is very different from reading them silently.)
- Encourage the children to read poems aloud to the group as well, but make this optional. We do not want children to develop a fear and dislike of poetry! If they are going to read aloud, make sure they practice several times.
- Don't have more than three or four children read aloud to large groups. If more want to read aloud, divide the audience into different listening groups. Too many poems read aloud in which families can't hear well or understand can be disappointing.
- Keep the poetry lesson short, even if you only share a few points.
- Allow the families to illustrate their written poems if they wish.
- Make copies of the poems to create a classroom family poetry book for the school library.
- Invite local media, school board members, or school district personnel to read the poems.
- Teach a whole poetry unit before or after the Poetry Family Morning.

For Families Who Cannot Attend Poetry Family Morning

For families who cannot attend Poetry Family Morning, send a note home saying you missed them. Then, provide copies of a few of the most popular poems read aloud and send them home with the students. Find a time during the school day when all your students have an opportunity to read and reread the poems planned for Poetry Family Morning.

RESOURCES ●

Children's Poetry Collections

Foster, J., Ed. (2000). *My first Oxford book of poems.* Oxford: Oxford University Press.

Greenfield, E. (1986). *Honey, I love and other poems.* New York: HarperTrophy.

Prelutksy, J. (1976). *Nightmares: Poems to trouble your sleep.* New York: Greenwillow Books.

Prelutsky, J., & So, M. (Eds.) (1999). *The 20th century children's poetry treasury.* New York: Knopf.

Silverstein, S. (1991). *A light in the attic.* New York: HarperCollins.

Silverstein, S. (1974). *Where the sidewalk ends.* New York: HarperCollins.

Worth, V. (1996). *All the small poems and fourteen more.* Elgin, IL: Sunburst.

REPRODUCIBLES ●

For Poetry Family Morning, we provide a model invitation, a sign-in sheet (see Resource B), a blank agenda form, overhead transparencies to use for instruction (or for suggestions on making your own), and an evaluation form. Feel free to adapt any of these tools to meet your own students' and families' needs. Importantly, conduct the lesson on poetry *you* like.

Come and Have Fun Enjoying Poetry Together!

Date _____

Dear Family,

You are invited:

What: Poetry Family Morning

Who: Parents/guardians and children

Date:

Time:

Where:

Why: To hear and read poetry together and, if you want, to create a new poem. All reading and writing is optional! Enjoying poetry is about *hearing it read aloud.*

A light breakfast and coffee will be provided. No need to bring anything.

Please return the form below if you will be there!

YES! My family and I will attend the Poetry Family Morning on _____.

_____ _____

(Student's name) (Number of people)

Poetry Family Morning

Welcome Families! Please sign in, put on a name tag, and then follow this agenda.

When?	What?	Where?	Who?
	Sign in and breakfast		All
	Welcome and read-aloud		All
	Mini-lesson on poetry		All
	Writing time (or reading time)		Families
	Sharing time		All
	Closing words and evaluation forms		All

On Poetry

Why Read Poetry?

Children love language that is repetitive, rhythmic, and fun.

 songs

 nursery rhymes

 raps

 chants (jump rope)

Poetry is about life—we can learn so much from it.

What Kills the Love of Poetry?

One "right" interpretation

Requiring the silent reading of poems

Having to write it so it rhymes

What Helps the Love of Poetry?

Read, read, and read more poetry.

Read, especially the poetry you enjoy.

Talk about what the poems make you think about.

Start with funny poetry; move toward more complex poetry.

When you write poems:

 They don't have to rhyme.

 They create an image or evoke a feeling.

 They are about everyday life.

Characteristics of Good Poetry

1. Poems are honest, about real life.

 Example:

 > Two roads diverged in a yellow wood,
 > and sorry I could not travel both
 > And be one traveler, long I stood
 > And looked down one as far as I could
 > To where it bent in the undergrowth;
 >
 > Then took the other, as just as fair,
 > And having perhaps the better claim,
 > Because it was grassy and wanted wear;
 > Though as for that the passing there
 > Had worn them really about the same,
 >
 > And both that morning equally lay
 > In leaves no step had trodden black.
 > Oh, I kept the first for another day!
 > Yet knowing how way leads on to way,
 > I doubted if I should ever come back.
 >
 > I shall be telling this with a sigh
 > Somewhere ages and ages hence:
 > Two roads diverged in a wood, and I—
 > I took the one less traveled by,
 > And that has made all the difference.

 (From "The Road Less Traveled" by Robert Frost)

2. Poems have concise, precise language. They don't have unnecessary words. Poets try to find exactly the *right* word.

 Example:

 > The air is damp, and hush'd, and close
 > As a sick man's room when he taketh repose
 > An hour before death;

 (From "A Spirit Haunts the Year's Last Hours"
 by Alfred Lord Tennyson)

(Continued)

3. Poems create an image through literary devices such as:

Repetition

Example:

> I lift mine eyes against the sky,
> The clouds are weeping, so am I;
> I lift mine eyes again on high,
> The sun is smiling, so am I.
> Why do I smile? Why do I weep?
> I do not know; it lies too deep.

> (From "I Lift Mine Eyes" by Mary Coleridge)

Alliteration

Example:

> The lake lay blue below the hill,
> O'er it, as I looked, there flew
> Across the waters, cold and still,
> A bird whose wings were palest blue.

> The sky above was blue at last,
> The sky beneath me blue in blue,
> A moment, ere the bird had passed,
> It caught his image as he flew.

> (From "The Bluebird" by Mary Coleridge)

Rhythm

Example:

> I know a place where the sun is like gold,
> And the cherry blossoms burst with snow,
> And down underneath in the loveliest nook
> Where the four leaf clovers grow.

> One leaf is for hope, and one is for faith,
> And one is for love, you know
> And God put another one in for luck,
> If you search you'll find where they grow.

> But you must have hope, and you must have faith
> You must love and be strong, you know
> If you work, if you wait,
> You will find where the four leaf clovers grow.

> (From "Four Leaf Clover" by Ella Higginson)

(Continued)

Rhyme

Example:

> Some say the world will end in fire,
> Some say in ice.
> From what I've tasted of desire
> I hold with those who favor fire.
> But if it had to perish twice,
> I think I know enough of hate
> To know that for destruction ice
> Is also great
> And would suffice.

> (From "Fire and Ice" by Robert Frost)

Metaphor—suggesting one thing is something else

Example:

> I am immortal! I know it! I feel it!
> Hope floods my heart with delight!
> Running on air made with life, dizzy, reeling,
> Upward I mount—farther in sight, life is feeling,
> Hope is the day—start of night!

> (From "Dryad Song" by Margaret Fuller)

A story

Example:

> A neighbor of mine in the village
> Likes to tell how one spring
> When she was a girl on the farm, she did
> A childlike thing.

> One day she asked her father
> To give her a garden plot
> To plant and tend and reap herself,
> And he said, "Why not?"

> (From "A Girl's Garden" by Robert Frost)

How Was Poetry Family Morning?

What did you like most about the Poetry Family Morning?

For children: What did you learn about poetry?

For children: Which was your favorite poem? Why?

What suggestions would you make for Family Nights or Mornings in the future?

How else can we work together to help your child?

Other comments:

12

Making Science Fun Family Night

WHY DO MAKING SCIENCE FUN FAMILY NIGHT? ●

Science is often one of the scariest topics for teachers and the most exciting for children. It can be scary because the knowledge base in science is constantly changing and we feel unable to keep up with it. Yet, that is one of the very reasons science is exciting to children: It is all about what is happening in our world, which is rapidly changing each day.

Our goals in providing Making Science Fun Family Night are to help teachers and families explore science together in fun ways, to see science in their everyday world, and to become wonderers and questioners about how things work and live. We think that science is one area in which all can learn together through hands-on exploration. Even if more questions are raised than answered in Making Science Fun Family Night, we are helping children and their families see that science is about careful observation of our world and the recording of what we see, hear, smell, taste, and touch. Science is about asking questions as well as answering them.

Making Science Fun Family Night takes a bit more preparation than some of the others, but we think it is well worth it. Author McIntyre conducted each of these experiments with three different groups: fourth graders, preservice student teachers, and in-service teachers. The first lesson she learned is that the younger the participants, the more demonstration and explicit instruction are needed. One mistake McIntyre made was giving a lead member of each of the small groups of students a hammer

and then expecting them to do exactly what they were told and nothing more. The students wanted to hammer everything! So, we recommend that either the parents do the actual hammering or that the teachers hold the parents to watching the children in their science exploration group very closely. The second lesson learned when doing these experiments with children and adults is that preparation is essential. Have all materials very organized before the Family Night begins. Also, have books on related topics nearby, so that if one group finishes before the others, the members can read while they wait. (Be sure to explain that this is part of the plan!)

We also recommend that you try out the three tests (for brittleness, hardness, and density) yourself or with your own family before doing them with your students' families. This way, when doing it at the Family Night, you can focus on using the science language we provide in our "Explanations for Discussion" section.

We encourage you to adapt the Family Night ideas to your students and families. For example, you can get the parents to gather the materials for these tests so they feel much a part of the planning for Making Science Fun Family Night. You can invite different parents or guardians to lead different experiments and explanations, if they feel able to do so. You might want to find ways to have great science literature read at this time. (Science and books do go together!) Many follow-up activities can be created to extend the learning. In any case, make Science Family Night enjoyable like the others.

Purpose

The purpose of Making Science Fun Family Night is to get children and parents to explore the physical matter in their environment and learn science concepts, principles, and language through the use of everyday materials.

Connections to National Standards

The National Science Teachers Association standards (1996) included in this Family Night are an understanding of:

Properties of objects and materials

Position and motion of objects

Change, constancy, and measurement

Science as a human endeavor

Content of Making Science Fun Family Night

In this Family Night, the teacher demonstrates how to explore everyday materials in our world using the "Directions for Doing Science" provided at the end of this chapter. The teacher uses scientific language (included in the "Explanations for Discussion" section) during the demonstration. Then the teacher reviews the rules for safety. In particular, the teacher needs to demonstrate a short, sharp tap of the hammer on the everyday items to test for properties of matter. The teacher demonstrates

that the tester does not raise his or her arm with a hammer. The teacher then has the families explore materials in similar ways using the hammer, bowl, pen cap, and everyday materials that the family brought. One person in the family acts as a scribe to record data. After the testing and recording, the teacher asks the families to move away from the materials and bring their recording sheets for a discussion. The teacher asks questions and explains the principles or concepts after the exploration. In this example, the families test items for hardness, brittleness, and density of solids, but this Family Night can be adapted to any concepts the teacher wants to communicate.

Grade Level Appropriateness

The experiments provided here are appropriate for all ages. Older children will come away with deeper, more complex understandings of some of the principles.

ORGANIZING MAKING ● SCIENCE FUN FAMILY NIGHT

Procedures

1. Use the Planning Guide (see Resource A) to organize Making Science Fun Family Night.

2. Arrange for the families to have a lot of table space.

3. Explain that you will demonstrate how to explore some of the matter the families brought with them.

4. Spread a few items on the table in front of you and explain that you will test your everyday items for *brittleness*. Then, demonstrate: Select an item and cover it with cloth or a towel. Say, "I am going to give this a short, sharp tap with a hammer. But first I need to predict what will happen to it when I hit it."

5. Make the prediction. Record your prediction on a sample Recording Sheet, which may be on an overhead projector for all to see.

6. Give the item a short, sharp tap with the hammer. Note what happens when it is struck. Tell the families whether the item bent, cracked, broke, or nothing happened.

7. Record the result on the Recording Sheet.

8. Tell the families they will be doing the same for their items. They will receive directions and a Recording Sheet. Suggest that various family members take different roles, such as selecting the item, predicting, tapping, and recording.

9. Tell the families they should get through all three tests if possible.

10. Review the safety rules. Post them where all can see.

11. After the families explore, have them share their recordings and discuss the concepts. This debriefing time is important for understanding the concepts explored.

12. Complete the evaluation forms and give closing words.

Suggested Agenda

5:30–5:55 Sign in; put on name tags; pick up agenda; eat.

Dinner: A variety of sandwiches, carrot sticks, cookies, and drinks

5:55–6:00 Welcome families; give directions for evening.

6:00–6:20 Demonstrate how to do activity; share rules for safety.

6:20–7:00 Families explore science together in small groups.

7:00–7:15 Reconvene to large group and share insights.

7:15–7:30 Share closing words and complete evaluation forms.

Materials

Invitations

Agendas

Sign-in sheet

Name tags

Food, drinks, and paper products

Evaluation forms

Materials from home, school, or yard (explained below)

Hammers (every family must have one)

Plastic pen caps (every family must have one)

Large bowls or tubs (every family must have one)

Old kitchen towels (every family must have one)

Water to fill each bowl halfway

Paper towels or rags to clean up water spills

Rules for Safety

"Directions for Doing Science" for every family

Recording Sheets for every family

Explanations for Discussion

Definitions

Tips

- Safety is always first in any science experiment, but especially when children handle tools like hammers. Remind families repeatedly about safety and have the rules posted where everyone can see them.
- Do the tests yourself once with a few students or family members at home, to be sure the demonstrations and explanations are very clear before the Family Night.
- Teach the families your rule for getting their attention (such as turning out the lights, a clapping pattern, etc.). This Family Night can be noisy and you will need to get the families' attention from time to time.
- Set time limits for testing the materials (10 minutes for each test might be appropriate), with 10 minutes for cleanup. Monitor the groups and help as needed.
- Bring sets of materials for the families who forget or cannot bring them.
- These activities lend themselves to excellent graphing activities, and you may want to incorporate them into the Family Night or later when back in class. If you do this, hang the graphs where parents and guardians can see them when they visit the school.

For Families Who Cannot Attend
Making Science Fun Family Night

For families who cannot attend Making Science Fun Family Night, send a note home saying you missed them. Then, if possible, find a time during the school day when the children who did attend the Making Science Fun Family Night can teach the other students what was learned. Allow the children who had not attended to try one or two of the experiments, assisted by students who are experienced. This arrangement can be a very effective learning experience for all.

RESOURCES ●

Science Books for Children

Cooper, C. (1992). *Matter: Exploring the amazing world of matter—from the earliest ideas of the four elements to the latest discoveries of the atom.* New York: Dorling Kindersley.

Hann, J. (1991). *How science works: 100 ways parents and kids can share the secrets of science.* New York: Dorling Kindersley.

Walpole, B. (1988). *175 experiments to amuse and amaze your friends.* New York: Random House.

REPRODUCIBLES ●

For Making Science Fun Family Night, we provide a model invitation, a blank agenda form, a sign-in sheet (see Resource B), overhead transparencies for teaching, handouts, and an evaluation form. Feel free to adapt any of these tools to meet your own students' and families' needs.

Come and Explore the World Together!

Date _____

Dear Family,

You are invited:

 What: Making Science Fun Family Night

 Date:

 Who: Parents/guardians and children

 Time:

 Where:

 Why: To get children and parents to explore the physical matter in their environment and learn science concepts, principles, and language.

A light dinner and drinks will be provided.

To explore science, we need many materials! But they are all easy to find. You need to bring: a hammer, a large bowl or bucket, an old kitchen towel, and a pointed plastic pen cap (like from an old Bic pen). Also, bring 12 *small* "everyday" items from your home that you will not mind losing. You can choose what they are. Some good examples are a stick, a stone, an aspirin, a plastic bottle, a candle, a crayon, a key, a bar of soap, a nut, some clay, a wooden spoon, a mirror, a nail, a marble, a pen, a pencil, a ball of paper, a stick of gum, a rubber ball, or a small toy. Do not bring anything valuable!

Please return the form below if you will be there.

--

YES! My family and I will attend Making Science Fun Family Night on _____.

_____ _____
(Student's name) (Number of people)

Making Science Fun Family Night

Welcome Families! Please sign-in, put on a name tag, and then follow this agenda for the evening.

When?	What?	Where?	Who?
	Sign in and dinner		All
	Welcome and demonstration, directions, rules for safety		All
	Families explore science		Families
	Share recordings and new insights		All
	Closing words and evaluation forms		All

Rules for Safety

1. While the tester is testing, everyone else observes and does not touch the other items.

2. Always use a kitchen towel or other cloth as a cover before testing for brittleness. If the towel does not cover the item, do not test it.

3. Use only a short, sharp tap of the hammer. For young children, it is best if a parent does the hammering.

4. Follow directions carefully.

5. If you spill water, wipe it up right away.

6. Safe science is fun science!

Thinking Questions for Families

What does *brittle* mean? Why do we need to know about brittleness?

Put the items in order from softest to hardest. What can you say about the hardness of items?

Which items are most *dense?* Why, do you think?

Directions for Doing Science

First, you will test your everyday items for *brittleness*. Then, you will test the same items for *hardness*. Finally, you will test the items for *density*.

Testing for Brittleness

1. Select one person in the family to test each of the items. The others observe and answer questions. Select one person to record predictions and results.

2. The tester *must use the cloth* to cover the items. (The others sit back a bit.)

3. The tester selects one item, puts it on a hard surface (table or floor), and covers it with a cloth. The observers *predict* what will happen when it is hammered. The recorder writes the predictions.

4. The tester gives the item a short, sharp tap with the hammer. Note what happens when it is struck. Does it bend, crack, break, or withstand the blow? Write the results about each one on the Recording Sheet.

Testing for Hardness

1. Choose another family member to test for hardness.

2. The tester selects an item and asks the group to predict whether it will be easy, hard, or really hard to scratch. The recorder writes the predictions on the Recording Sheet.

3. The tester uses the plastic pen cap to scratch each item. The group notes how hard you have to press to scratch each substance. Was it easy to scratch? Hard to scratch? Really, really hard to scratch?

4. The recorder fills out the Recording Sheet.

Testing for Density

1. Fill your bowl or bucket halfway with water.

2. Choose a tester. The tester selects an item, and the group predicts whether it will sink or float. The recorder writes the predication on the Recording Sheet.

3. The tester tests each item to see if it sinks or floats.

4. The recorder fills out the Recording Sheet.

5. If you have clay, make it into a ball and test it. Now make the clay ball into a boat. See if it floats. What is the difference? Why?

These experiments were adapted from the resources listed at the end of this chapter.

Recording Sheet

Item	Brittleness Result of hammer	Hardness Easy, hard, very hard	Density Sink or float?
1.	Prediction: Result:	Prediction: Result:	Prediction: Result:
2.	Prediction: Result:	Prediction: Result:	Prediction: Result:
3.	Prediction: Result:	Prediction: Result:	Prediction: Result:
4.	Prediction: Result:	Prediction: Result:	Prediction: Result:
5.	Prediction: Result:	Prediction: Result:	Prediction: Result:

Mock Recording Sheet

This mock recording sheet shows what a recording sheet might look after three items are given all three tests.

	Brittleness	**Hardness**	**Density**
Item	*Result of hammer*	*Easy, hard, very hard*	*Sink or float?*
1. stick	Prediction: *Will break* Result: *Didn't break*	Prediction: *Won't scratch* Result: *Scratches a little bit*	Prediction: *Will sink* Result: *Floats!*
2. stone	Prediction: *Won't break* Result: *Didn't break*	Prediction: *Won't scratch* Result: *Scratches*	Prediction: *Will sink* Result: *Sinks!*
3. plastic bottle	Prediction: *Will bend* Result: *Doesn't break or bend*	Prediction: *Won't scratch* Result: *Doesn't scratch*	Prediction: *Will float* Result: *Floats!*
4.	Prediction: Result:	Prediction: Result:	Prediction: Result:
5.	Prediction: Result:	Prediction: Result:	Prediction: Result:
6.	Prediction: Result:	Prediction: Result:	Prediction: Result:
7.	Prediction: Result:	Prediction: Result:	Prediction: Result:

Explanations for Discussion

Definitions:

Brittle. A substance is brittle if it breaks easily. It can be hard but still break. Some things you can bend but not break.

Hard. One way to test the hardness of something is to see how easily it scratches. If it scratches easily with the plastic pen cap, it is soft. If it is hard to scratch, it is hard.

Dense. How heavy something is in relation to its size is its density. If a baseball is smaller than a beach ball, but heavier, it is *denser.*

Explanations:

- When talking about the properties of materials, scientists do not just say something is hard, brittle, or dense, but they compare it to other things. For example, "It is more brittle than _____ but less brittle than _____."

- Scientists and engineers need to know about the brittleness and hardness of materials to know what materials should be used to make certain things.

- If something is denser than water, it will sink. If the item floats, it is less dense than water. Why do ships float? They have air in their hulls. And they take up a lot of space (have volume). Both of these reasons make the ship float. That is why the clay ball made into a boat will float, even though it is the same amount of clay. It takes up more space and has air in the open space.

How Was Making Science Fun Family Night?

What did you like most about this Family Night?

For children: What is something new you learned about materials in our world?

What suggestions would you make for Family Nights in the future?

How else can we work together to help your child?

Other comments:

13

Fun With Language

*A Family Night of Riddles,
Jokes, and Cartoons*

● **WHY DO RIDDLES, JOKES,
AND CARTOONS FAMILY NIGHT?**

From young children first telling "knock-knock—who's there?" jokes to adults lamenting the end of the "Calvin and Hobbes" cartoon, we all tend to respond in a positive way to the playful use of language. We enjoy being stumped by a clever riddle, begin presentations with a joke to connect with an audience, and appreciate political cartoons that reflect our own perspectives. But we don't often take the time to think very deeply about riddles, jokes, and cartoons. We experience them, maybe pass them along to someone else, and get on with other activities.

However, to understand riddles, jokes, and cartoons requires a degree of sophistication with language, an awareness of the nuances of word meanings and context clues. A night devoted to riddles, jokes, and cartoons on the surface brings families together to have fun with language, to laugh at the clever creations of others, and to try to create their own. On another level, though, this Family Night helps everyone develop a bit more understanding about language and its uses, in this case how language can convey humor or cleverness or a point of view.

These language skills applied to riddles, jokes, and cartoons parallel the kinds of skills needed in reading other kinds of texts. As readers, we need to understand an author's intent, recognize how an author develops an idea, and discern the perspective embedded in an author's choice of words. So, this enjoyable Family Night can help strengthen language skills that have a wider application. We suggest that you begin the evening with riddles, jokes, and cartoons placed on tables for the families to enjoy as they have dinner together.

Purpose

The purpose of this Family Night is to experience fun language together and to create riddles, jokes, and/or cartoons.

Connections to National Standards

This Family Night reflects several of the National Council of Teachers of English (NCTE) and the International Reading Association (IRA) standards (2002), such as:

Students read a wide range of print and nonprint texts.

Students apply a wide range of strategies to comprehend, interpret, evaluate, and appreciate texts.

Students adjust their use of spoken, written, and visual language to communicate effectively.

Students employ a wide range of strategies as they write and use different writing process elements appropriately to communicate.

Content of Riddles, Jokes, and Cartoons Family Night

For this Family Night, teachers begin by sharing a favorite joke, riddle, and cartoon that will engage the families and then invite students or their family members to share one of their favorite riddles, jokes, or cartoons. After the sharing, the teacher leads a discussion of what makes a riddle, joke, or cartoon "work." Following the sharing and discussion, the families create a riddle, joke, or cartoon (or more than one) together, using the materials provided. They share these in small groups, add theirs to the "Riddles, Jokes, and Cartoons" book created at the end of the evening, and complete the evaluation form.

Grade Level Appropriateness

The Riddles, Jokes, and Cartoons Family Night can be adapted for all grade levels. Be sure to have a variety of riddle and joke books as well as cartoons from books, magazines, and newspapers.

● ORGANIZING RIDDLES, JOKES, AND CARTOONS FAMILY NIGHT

Procedures

1. Use the Planning Guide (see Resource A) to organize Riddles, Jokes, and Cartoons Family Night.

2. If possible, decorate the room with poster-size cartoon characters. Invite your students to create these ahead of time.

3. Before everyone arrives, place several examples of riddles, jokes, and cartoons on the tables for the families to share and enjoy as they have dinner.

4. Before the evening, choose a favorite riddle, joke, and cartoon to share. Be sure to have one of each and make sure they would not be offensive in any way to those attending. Make a transparency of the cartoon and practice ahead of time how best to tell the riddle and joke and read the cartoon.

5. After dinner, get everyone together and start the evening by sharing your examples.

6. After the sharing, lead a discussion of what makes a joke, riddle, or cartoon "work." This may provide an opportunity as well to talk about what is not okay—jokes or cartoons that make fun of others or use offensive terms about groups of people.

7. Invite the students or their family members to share one of their favorite jokes, riddles, or cartoons. You may want to do this sharing in small groups if many attend the Family Night.

8. Provide time for families to create a joke, riddle, or cartoon (or more than one) together, using the materials provided.

9. Depending on the number attending, encourage the families to share their creations in either small groups or with the larger group.

10. Ask the families to add what they have produced to a group "Jokes, Riddles, and Cartoons" book at the end of the evening. Mention that the book will be placed in the school library for all to enjoy.

11. For those who really want to take their creation home, ask if you can keep it long enough to make a copy the next day for the book and then send it home.

12. Encourage the families to complete the evaluation forms together, except for questions specifically addressed to the children.

Suggested Agenda

5:30–5:55 Sign in; put on name tags; pick up agenda; eat.

Dinner: Chili, crackers, celery sticks, cheese, and soft drinks

5:55–6:00 Welcome families; give directions for evening; make transition to activity.

6:00–6:15 Share favorite riddles, jokes, and cartoons.

6:15–6:30 Discuss what makes a riddle, a joke, or a cartoon.

6:30–7:00 Families create own riddles, jokes, and/or cartoons.

7:00–7:15 Share in small groups; create group book of all riddles, jokes, and cartoons.

7:15–7:30 Complete evaluation forms and give closing words.

Materials Needed

Invitations

Agendas

Sign-in sheet

Name tags

Food, drinks, and paper products

Evaluation forms

Overhead projector

Sample riddles, jokes, and cartoons

Books of riddles, jokes, and cartoons

Transparency of "What Makes a Riddle, Joke, or Cartoon?"

Different colors of 8 ½ by 11 paper already hole-punched

Pens and pencils

Various markers and crayons

Tips

- A few days before the event, encourage your students to bring in some riddles, jokes, and cartoons that will be placed on the tables to read and share while eating dinner. Share some of these in class to help the students understand them and to generate interest in the Family Night.
- Invite the students to create large cartoon characters that will be used to decorate the room for the Family Night. You might use a poster maker.
- If your school has a morning TV program, promote the Family Night with a daily riddle or joke the week leading up to the event.
- Dress up as a cartoon character for the evening.
- Practice, practice, practice the riddles, jokes, and cartoons you will share!
- Have lots of books of riddles, jokes, and cartoons available for ideas when the families create their own.

- Be sure to have some examples in the languages of all the families who might attend.
- Put the book that the families create in the library for all to enjoy.
- All children can tell jokes. (They may not be funny, but they can tell them.)

For Families Who Cannot Attend
Riddles, Jokes, and Cartoons Family Night

For families who cannot attend the Family Night, send a note home saying that you missed them. Give the students the "What Makes a Joke, a Riddle, or a Cartoon?" handout, a sample of each, and some of the hole-punched paper. Teach them the information from the evening and encourage them to teach their families and create additions for the book. When they bring their products back to school, provide time for them to share with the class.

● RESOURCES

Books of Riddles, Jokes, and Cartoons

Cole, J., Calmenson, S., Tiegreen, A., & Cohn, A., Eds. (1994). *Why did the chicken cross the road? And other riddles old and new.* New York: Beech Tree Books (William Morrow.)

Downs, M., & Sheldon, D. (2002). *Pig giggles and rabbit rhymes: A book of animal riddles.* San Francisco: Chronicle Books.

Fremont, V., & Daste, L., Eds. (1998). *Knock, knock jokes.* Mineola, NY: Dover.

Pilkey, D. (2002). *The new Captain Underpants collection: Box set (books 1–5).* New York: Blue Sky Press.

Poploff, M., & Basso, B. (1998). *Bat bones and spider stew.* New York: Bantam Doubleday Dell.

Schulz, C. (2000). *Peanuts 2000: The 50th year of the world's favorite comic strip.* New York: Ballantine Books.

● REPRODUCIBLES

For Riddles, Jokes, and Cartoons Family Night, we provide a model invitation, a blank agenda form, a blank sign-in sheet (see Resource B), a handout, and an evaluation form. Feel free to adapt any of these tools to meet your own students' and families' needs.

Come and Share Some Riddles, Jokes, and Cartoons With Your Child!

Date _____

Dear Family,

You are invited:

 What: Riddles, Jokes, and Cartoons
 Family Night

 Who: Parents/guardians and children

 Date:

 Time:

 Where:

 Why: To enjoy the fun language of riddles, jokes, and cartoons
 and create some, too!

A light meal and drinks will be provided. You do not need to bring anything. If you have a favorite riddle, joke, or cartoon, be prepared to share it. (Be sure it would not offend others!)

Please return the form below if you will be there.

--

YES! My family and I will attend the Riddles, Jokes, and Cartoons Family Night on _____.

_____ _____

(Student's name) (Number of people)

??? Riddles, Jokes, and Cartoons Family Night ☺ ☺ ☺

Welcome Families! Please sign in, put on a name tag, and then follow this agenda for the evening.

When?	What?	Where?	Who?
	Sign in and dinner		All
	Welcome and examples		All
	What makes a riddle, etc.?		All
	Creating a riddle, etc.		Families
	Sharing		Small groups
	Closing words and evaluation forms		All

What Makes a Riddle, a Joke, or a Cartoon?

- A riddle gives clues to guess something.

- A joke is a short story or remark that is funny or clever and is intended to make people laugh.

- A cartoon is a drawing with a story. It sometimes has words that people say in bubbles.

- Riddles, jokes, and cartoons often have something surprising in them, like people or animals doing things they do not usually do.

- Riddles, jokes, and cartoons often have something funny, like a clever use of language or a funny thing that happens.

- How you tell a riddle or joke makes a big difference in whether others find it funny!

How Was Riddles, Jokes, and Cartoons Family Night?

What did you like most about this Family Night?

For children: What was your favorite riddle, joke, or cartoon? Why?

What was the hardest thing about creating your own riddle, joke, or cartoon?

What suggestions would you make for Family Nights in the future?

How else can we work together to help your child?

Other comments:

14

Health and Wellness Family Night

WHY DO HEALTH AND WELLNESS FAMILY NIGHT? ●

We have all read the alarming statistics about childhood obesity, "adult-onset" Type II diabetes in children and adults, cancer risks, drug and alcohol abuse, and the many other health-related problems that challenge our country. Television commercials inform us repeatedly of the latest drug to cure whatever ails us, followed by more commercials encouraging us to eat more fast food and to "supersize" our orders. We latch on to the latest diet craze and make New Year's resolutions every January about eating better and exercising more, resolutions we often break before February.

Certainly a Family Night focused on health and wellness will not cure all of these problems, but it can be a first step in raising awareness and helping everyone (teachers included!) have better information and think about making better choices. The information shared focuses on the importance of good nutrition and what that means about food types, portion size, and a balance of selections. The information also focuses on the importance of exercise and how it can become a part of everyone's daily routine without joining a fitness center, trying out for a sports team, or investing money in expensive equipment.

As is true for all of the Family Nights, the main goal is being together for an enjoyable and informative time that can lead to more parent and family involvement and ultimately improve student academic achievement.

Purpose

The purpose of this Family Night is to learn strategies for developing and maintaining a healthy lifestyle from childhood through adulthood.

Connections to National Standards

This Family Night reflects standards of the National Association for Sport and Physical Education (NASPE) and the American Association for Health Education (AAHE). These standards focus on having students:

Participate regularly in physical activity.

Achieve and maintain a health-enhancing level of physical fitness.

Value physical activity for health, enjoyment, challenge, self-expression, and/or social interaction.

Comprehend concepts related to health promotion and disease prevention.

Content of Health and Wellness Family Night

You can certainly plan and implement this Family Night on your own, using only the suggested activities and materials we provide. Or you can plan and coordinate this Family Night to involve others, such as the cafeteria staff in your school or the nutrition, health, or physical education resource staff for your district. Representatives from your local health and parks and recreation departments and community organizations such as the American Heart Association, American Cancer Society, and American Diabetes Association might also be eager to participate. They might help with activities (health screenings and assessments) and offer helpful materials for use during the Family Night and for participants to take home.

The evening begins with a healthy meal, of course! The choices need to reflect the emphasis of the evening on good nutrition and good food choices. This is a great time to help everyone discover that healthy food can also taste good. We are including a recipe for Three Bean Soup from the Web site of the Centers for Disease Control and Prevention.

After the meal, briefly share the information provided and have a general discussion about nutrition, exercise, and good health (and the challenges involved in staying healthy). Then, provide time for the families to make their own healthy dessert and complete either their food or exercise planning (or both if they want to and have enough time). Reconvene to share ideas, listen to a funny food poem, and complete the evaluation forms.

Grade Level Appropriateness

The Health and Wellness Family Night is appropriate for all grade levels.

ORGANIZING HEALTH AND ● WELLNESS FAMILY NIGHT

Procedures

1. Use the Planning Guide (see Resource A) to organize Health and Wellness Family Night.

2. Share the information and have a general discussion about good nutrition and exercise.

3. If possible, bring in examples of recommended portion sizes for various foods.

4. Show a transparency of either the "Fruits and Vegetables for Our Family" or the "Let's Get Moving Chart" that you have filled out for yourself for the past week.

5. Provide directions for making the healthy dessert and ask the families to take turns making their own during the activity time.

6. Provide time for the families to make the dessert and fill out their own "Fruit and Veggie Record" or the "Record of Exercise Minutes."

7. Circulate among the families to answer questions, help out if needed, and just get to know them better.

8. Reconvene as a whole group to share ideas, join you in *your* commitment to eat more nutritious meals and to exercise more (especially as a family), and listen as you read a funny food poem.

9. Encourage the families to complete the evaluation forms together, except questions specifically addressed to the children.

Suggested Agenda

5:30–5:55 Sign in; put on name tags; pick up agenda; eat.

Dinner: Vegetarian chili, multigrain bread or whole wheat crackers, apple slices, water or juice

5:55–6:00 Welcome families and give overview of the evening.

6:00–6:15 Share information about nutrition and exercise.

6:15–7:00 Families make desserts and plans for healthy eating and/or exercise.

7:00–7:15 Reconvene for sharing; read poem.

7:15–7:30 Give closing words and complete evaluation forms.

Materials Needed

Invitations

Agendas

Sign-in sheet

Name tags

Food for dinner and desserts, drinks, and paper products

Evaluation forms

Overhead projector

Overhead transparencies

Handouts

Pens and pencils

Food poems

Tips

- Be sensitive to the fact that some in the audience may feel uncomfortable about their eating habits, weight, or lack of exercise.
- The point of the evening is not to make anyone feel guilty or embarrassed. Be sure to communicate that all of us can make better choices, you included.
- You might share some of your own good intentions and challenges about eating and exercise, such as finding time in already busy schedules, ideas for healthy and quick snacks (especially for children), ideas of what to pack for lunch, and so on.
- Explain that getting more information and making a do-able, short-term plan can be a good start.
- Suggest that this all works best if the whole family gets involved and finds a fun way to keep everyone motivated and on target.
- Think through the logistics of how the families will make their desserts. Set up two or three areas to ease crowding. Choose something that is not too complicated!
- This Family Night offers a great opportunity to involve community organizations such as the American Heart Association, American Cancer Society, and American Diabetes Association and can be well worth the time to make the contacts and arrangements for them to participate.
- Keep the message about healthy choices in mind in the classroom! If you use rewards, make choices other than candy or cookies and help the students understand why. Involve them in coming up with alternatives.
- Remember what a powerful influence you can be as a good role model. Share new information you have read about health and wellness. Talk about what you are having for lunch or a snack, how you are making sure you exercise, and how your own family members or friends are helping you to make healthy choices.
- You might offer an opportunity to all students interested in technology to explore Web sites that have information about health and wellness and then, with others with artistic talents or interests, create a Health and Wellness Center in the classroom full of information. Other students gifted or especially interested in mathematics might conduct a survey of class members about the kinds of food eaten in one or two weeks and the kinds of exercise engaged in.

They could then present the data in graph form for discussion about the class's baseline in making healthier choices. They could repeat this activity in a couple of months to determine if the class has changed in its habits.

For Families Who Cannot Attend Health and Wellness Family Night

For families who cannot attend the Family Night, send a note home saying you missed them. Send a packet home with the information from the evening, including any materials provided by community organizations or departments. Spend some time in the classroom talking about the menu-planning and exercise sheets. Those students who attended might want to share what they and their families are doing to help provide ideas for those who were not able to attend. Encourage everyone about making healthy decisions. And, of course, model this yourself.

RESOURCES ●

Food Poems

Silverstein, S. (1996). *Falling up.* New York: HarperCollins (Poems: Cereal, Big Eating Contest, Carrots).

Silverstein, S. (1974). *Where the sidewalk ends.* New York: HarperCollins (Poems: Pancakes, Peanut-Butter Sandwich, Spaghetti, Recipe for a Hippopotamus Sandwich).

REPRODUCIBLES ●

For Health and Wellness Family Night, we provide a model invitation, a blank agenda form, a blank sign-in sheet (see Resource B), handouts, an evaluation form, recipes, and Web sites to explore for more ideas. Feel free to adapt any of these tools to meet your own students' and families' needs.

Come Get Healthier With Your Child!

Date _____

Dear Family,

You are invited:

What: Health and Wellness Family Night

Who: Parents/guardians and children

Date:

Time:

Where:

Why: To learn about how we ALL (teachers included) can have a healthier lifestyle! A light meal and drinks will be provided. You do not need to bring anything.

Please return the form below if you will be there.

--

YES! My family and I will attend the Health and Wellness Family Night on _____.

_____ _____

(Student's name) (Number of people)

Health and Wellness Family Night

Welcome Families! Please sign in, put on a name tag, and then follow this agenda for the evening.

When?	What?	Where?	Who?
	Sign in and dinner		All
	Welcome and overview		All
	Information sharing		All
	Dessert and family plans		Families
	Sharing and poem		All
	Closing words and evaluation forms		All

 Fruits and Vegetables for Our Family

What fruits and vegetables do you like and eat most often? Apples? Bananas? Potatoes? Carrots? Many, many more choices are available. Take a look at the following lists. How many have you tried? Try some more! You just might find a new favorite on your way to healthier eating.

Fruits: Apples, apricots, bananas, blackberries, blueberries, cantaloupe, cherries, cranberries, figs, grapefruit, grapes, kiwi, mangoes, nectarines, oranges, papaya, peaches, pears, pineapple, plums, prunes, strawberries, tangerines, raspberries, watermelon

Vegetables: Artichokes, asparagus, barley, beans, beets, black-eyed peas, broccoli, cabbage, carrots, cauliflower, celery, collard greens, corn, cucumbers, eggplant, green beans, leeks, lentils, lettuce, lima beans, mushrooms, okra, onions, parsnips, peppers, potatoes, peas, snow peas, spinach, sprouts, squash, tomatoes, yams, turnips, water chestnuts, zucchini

Fruits and Vegetables We Like the Most:

Fruits and Vegetables We Plan to Try!

Eat Those Fruits and Veggies!

To be healthy, try to eat five to nine fruits and vegetables every day. Too many, you think? Keep in mind what a serving size is. Maybe this won't be so difficult after all. Challenge yourself and help others in your family. Use a copy of the "Fruit and Veggie Record" for each family member. Post the charts in the kitchen and keep track. See how you improve in your healthy eating!

What Is a Serving?

The "5-a-Day for Better Health Program" defines one serving as:

¾ cup or 6 oz., 100% fruit or vegetable juice

½ cup raw, cooked, canned, or frozen fruit or vegetables

½ cup cooked, canned, or frozen peas or beans

1 cup raw, leafy vegetables

1 medium-size fruit

¼ cup dried fruit

Source: http://www.cdc.gov/nccdphp/dnpa/5aday/pdf/5_a_day_energizing_tips.pdf

_____'s Fruit and Veggie Record for Week of _____

	Breakfast	Lunch	Snacks	Dinner	Total
Sunday					
Monday					
Tuesday					
Wednesday					
Thursday					
Friday					
Saturday					

Let's Get Moving!

We all know how important exercise is. Finding time for exercise is the challenge. Take a look at all of the ways we can exercise. Maybe this won't be so difficult after all! Challenge yourself and help others in your family.

Have each family member fill out a "Record of Exercise Minutes" chart for what you did this *past week*. Talk about it as a family. How did you do? Make a plan for *next week*. Take a chart home for each family member. Post them someplace convenient and keep track. See how you improve in getting healthier through exercise.

Consider All of These Types of Activities!

Acrobatics, aerobics, archery, badminton, ballet, baseball, basketball, baton twirling, bicycling, bowling, calisthenics, canoeing/kayaking, catch, cheerleading, clogging, cricket, croquet, curling, dancing, discus, diving, dodge ball, drill team, fencing, field hockey, fishing, flag football, football, Frisbee, four square, golf, gymnastics, hackey-sack, handball, hiking, hopscotch, horseback riding, hula hoping, hurdling, ice hockey, figure skating, inline skating, jai alai, javelin, jogging, judo, jump rope, karate, kickball, kick boxing, lacrosse, line dancing, logging, lunges, martial arts, mountain climbing, paddle ball, ping pong, pull ups, push ups, racquetball, rock climbing, roller hockey, roller skating, rowing, rugby, scooters, scuba diving, shot put, sit ups, skateboarding, ski jumping, skin diving, sledding, snowboarding, snow skiing, snorkeling, soccer, softball, square dancing, squash, step team, stick ball, stretching, surfing, swimming, tae bo, taekwondo, t'ai chi, tag, tennis, tetherball, tobogganing, track and field, tumbling, ultimate Frisbee, volleyball, walking, water polo, water skiing, weight lifting, wrestling, and yoga. And, these count, too: Dancing to your favorite music, household chores, mowing the lawn, participating in PE class, participating in recess, raking the leaves, tap dancing, walking the dog, washing the car, and working in the garden. What else can you add?

Sources: http://www.cdc.gov/nccdphp/dnpa/5aday/pdf/5_a_day_energizing_tips.pdf
 http://www.bam.gov/fit4life/calendar/index_quiz.asp

_____'s Record of Exercise Minutes for Week of _____

	Activity	Minutes
Sunday		
Monday		
Tuesday		
Wednesday		
Thursday		
Friday		
Saturday		
Weekly Total		

How Was Health and Wellness Family Night?

What did you like most about this Family Night?

For children: What was the most important thing you learned about being healthy and well? Why?

What is one thing your family might try in order to be healthier?

What suggestions would you make for Family Nights in the future?

How else can we work together to help your child?

Other comments:

Recipes

Yogurt Parfait

Ingredients

- 2 cups chunked canned pineapple
- 1 cup frozen raspberries
- 3 cups vanilla yogurt
- 1 medium peeled and sliced banana
- 1/3 cup chopped dates
- 1/4 cup slice toasted almonds

Add the pineapple, raspberries, dates, bananas, and yogurt in layers to a tall glass or sundae dish. Sprinkle almonds all over the top. Makes 4 servings.

Source: http://www.bam.gov/fit4life/treats_dessert_two.htm

Three Bean Soup

Serves 12

Source: Produce for Better Health

Ingredients

1 can (28 oz.) low-sodium tomatoes, cut up

3 cups water

1 tsp chili powder

1 can (15 oz.) kidney beans, drained

1 can (15 oz.) black-eyed peas, drained

1 can (15 oz.) garbanzo beans, drained

1 can (15 oz) whole kernel corn, drained

1 cup carrots, chopped

1 onion, medium, chopped

1½ tsp garlic, chopped

1 can (6 oz.) tomato paste

1 tbsp Dijon mustard

½ tsp pepper

½ tsp cumin, ground

1 tsp oregano, dried

1 tsp basil, dried

1 cup zucchini or celery, chopped

Combine first 13 ingredients. Bring to a boil. Reduce heat and simmer, covered, for 10 minutes. Stir in vegetables and simmer, covered, for 10 minutes more.

Nutritional analysis per serving: Calories 261, Fat 1g, Calories from Fat 2%, Cholesterol 0mg, Fiber 10g, Sodium 438mg, Protein 14g.

Source: http://www.cdc.gov/nccdphp/dnpa/5aday/month/beans.htm

15

Next Steps

Getting the Most Out of Family Nights

The Family Nights we have proposed in this book are only a beginning toward creating positive relationships with families for higher student achievement. Any of these events can be adapted to suit you and your school's needs. Or, you can take the format and plan your own Family Night on a topic of interest to you, your students and families, or your community. The important thing is to reach out and get started. We did, and we are glad we did.

Reflections on Doing Family Nights

After conducting most of these Family Nights (some we conducted multiple times) and then sitting down together to write this book, we reflected on what makes Family Nights successful and why they are so important to do. We all agreed that good planning and follow-up to the invitations are essential. Our motto is, "Leave nothing to chance," and we try to plan for every conceivable issue that might come up, such as food differences, crying preschoolers, appropriate space for events, and so on. The invitations should be clear, including the kind of food that will be served, so if the event only serves snacks, families do not come expecting a meal. To get good attendance, teachers can build up the event in the classroom while being careful not to make those students who cannot come feel excluded (see sections on adaptations for families who cannot attend). We also recommend making reminder calls to some families, especially if they are presenting or bringing something important.

At times, conducting a Family Night is a lot of work. So, why do it? All of us agree that the pay-off is well worth the extra effort. Much is made easier for the teacher for the rest of the year because of the positive relationships that are formed between parents and teachers at these events. Mutual trust is invaluable. Family members view the school as going the extra mile for their children. Teachers can see their students' parents not only as just parents, but also as adults with out-of-school lives. Further, these Family Nights can help assist parents in learning educational jargon and best practices and the reasons for particular practices. We have all heard the stories of parents who worry when their first grader is writing with invented spelling. At a Family Night, we can express that this practice is one of the most well-researched best practices for helping students to develop necessary phonological knowledge (National Reading Panel Report, 2000). Family Nights are a way to illustrate what is going on in the classroom and why.

Expanding Participation

We feel sure that once you have experienced the positive rewards of conducting Family Nights, you will do them every year. But some of your colleagues might be resistant. From a distance, it looks like a lot of hassle. So, how can we expand involvement in the school? First, we believe that requiring Family Nights is inappropriate. If teachers are unhappy about doing this, it will be communicated to parents, and not only will there be few benefits, it could be destructive. Sometimes when teachers are resistant, it is because they do not know how to conduct these events (which is why we wrote this book). But, seeing the results of another teacher can open minds and attitudes. Teachers can see there is not only one way to do this. Indeed, most anything that results in something good requires extra effort. If you want to do whatever it takes to reach your students, then you will want to find ways to reach out to their families. The families will appreciate what you are trying to do, and they in turn will work with you.

Back in the Classroom

The purpose of the Family Nights presented in this book is for higher student achievement. We believe that one avenue toward higher achievement is through working closely with the families. Yet, building positive relationships cannot stop there. As teachers and administrators, it is now our job to extend the Family Night event into the classrooms.

Research and learning theory have illustrated that people learn based on what they already know. Learning something new begins with our prior knowledge about the concept or skill (Tharp and Gallimore, 1993; Vygotsky, 1978). The challenge for teachers is to find out what their students know and are able to do and realize and implement the "next steps" that assist learners beyond what they can do and know on their own. Family Night events can be excellent sources for assessing what students know and can do, and the classroom is the place to build on it.

We recommend that, at times, you try to conduct a Family Night on a topic that you are teaching in the classroom. For instance, if you do a Pajama Party Family Night, the response journal activity can be an

introduction to writing in response to books, and this activity should be used again soon after the family event. If you are beginning a science unit on physical science, the Making Science Fun Family Night would be an excellent way to begin. Back in the classroom, students will eagerly read about, discuss, and do further science experiments when the work is built on the experiences they had with their families. Both Poetry Family Morning and Health and Wellness Family Night might lead directly into units of study on these topics.

If the Family Night does not lend itself to a unit of study, you can still build on the concepts, skills, and strategies experienced during the Family Night. In fact, it is essential for learning to make that connection. For example, if a reading strategy is taught during Family Night, reinforcement in school the following day is necessary. If you can find just a few minutes each day for several days after the Family Night to build on what was taught that night, the students will be able to connect their prior learning (at the Family Night) to new or related material taught in school.

Family Knowledge

To maximize learning theory, many educators are recommending that we build curriculum around what students and their families know (Moll and González, 2003). We must begin by finding out the talents, hobbies, skills, and professions of the families, and then attempt to use that information in the classroom as we read, write, and solve problems. Detailed examples of this kind of teaching can be found in McIntyre, Rosebery, and González (2002). Family Nights can be a way of beginning to move toward this pedagogy. For instance, during the Hobbies, Talents, and Interests Family Night, take good notes about what the families have in common. Is there a topic upon which you can build curricular strategies and skills? If many like golf, can you search through history to find famous people, such as presidents, who also liked golf? If the families are adept at cooking, can you find ways to use their recipes for a reading lesson? (They make excellent reading lessons because they take a lot of inferencing.) Can you use the recipes for lessons on measurement?

To elicit more of what families know and can do, use the evaluations we provide to find out the topics of interest to them. It is important to respond to suggestions in some way, even if you only do part of an event someone suggests. Let families know you value their opinions and interests. Finally, if some families seem reluctant to share what they know, call them and express your interest in what they do. Often families might not know you are interested in nonschool-like activities.

Beyond the School: Community-Based Organizations

Community-based organizations (CBOs) are groups that assist families in obtaining health and education information and services. Many schools are partnering with community-based organizations in efforts to help students achieve academic success through getting basic needs addressed first (Adger and Locke, 2000). As one way to extend family involvement in schools, we recommend that teachers and administrators seek out the CBOs in their school's community to build on the work that is being done there.

What do CBOs do? There are hundreds of different kinds of CBOs that assist students and families in ways that can ultimately affect academic success. Some organizations provide programs that assist families with child care, health care, prenatal care, and alcohol and drug prevention. Some provide programs offering English language classes, GED classes, after-school programs, and tutoring. Many of these organizations have the same or similar goals to our own as teachers. Thus, it is not surprising that research has shown that some school and CBO partnerships have raised student achievement of students thought to be at risk for school failure (Adger and Locke, 2000).

The primary way schools have been able to assist CBOs is by referring families to programs they might need or want. One school created a parent center at the school, which was simply a place for parents to convene, get acquainted, and share information. Brochures from the CBOs were available, and teachers and principals stopped by to welcome families as they saw them.

Additionally, once you have found out what kinds of programs are offered, you might want to invite key people to events at your school, such as Family Nights. If a program offers tutoring to some of your students, you will want them to attend the nights when you teach strategies, such as Family Reading Night.

Other partnerships can be more elaborate. In Seattle, Washington, "Project Look" operates three "schools" in apartment buildings in which many of the students live to provide a safe place for children in grades 1–6 to come after school for help with homework and tutoring. It began with a focus on academics but was expanded to include prevention of alcohol, tobacco, drop out, and violence. During school hours there are programs for parents such as GED preparation and language classes. Project Look grew out of a conversation between a teacher, a principal, and a university professor and now includes 35 different community organizations (Adger and Locke, 2000).

Working together always results in more than what is accomplished working alone. Just being seen in the community can also be beneficial. Some families who see familiar faces in one setting (e.g., school) might well be interested in becoming part of another setting (a CBO). This is all part of the trust-building that we discussed in Chapter 1, an essential ingredient for successful family and school relationships and the first step toward higher student achievement. Family Nights as presented throughout this book can help to begin a process that ultimately leads to long-term positive results.

Resource A: Reproducible Planning Guide

Event: _____

Date: _____ Time: _____ Location: _____

Given by: _____

Things to Do	Person(s) Responsible	Timeline

- ➤ Check with/inform principal
- ➤ Decide speakers and other roles
 - o Whole group
 - o Small groups
 - o Sign-in table
- ➤ Decide food and paper products needed

- ➤ Prepare and send invitations
- ➤ Prepare invitations for English-language learners
- ➤ Collect materials needed
- ➤ Prepare materials
- ➤ Purchase food
- ➤ Publicize the event
- ➤ Prepare sign-in sheets/name tags
- ➤ Prepare room(s)
- ➤ Prepare food
- ➤ Clean up
- ➤ Display products in school
- ➤ Prepare and send follow-up notes
- ➤ Contact families who missed the event
- ➤ Review and summarize evaluation information
- ➤ Other tasks:

Resource B:
Reproducible
Sign-In Sheet

Sign-In Sheet for _____

Date _____

Welcome Families!

Parent/Guardian in Attendance	Child or Children in Attendance and Ages

Resource C: Helpful Web Sites

www.aahperd.org/aahe/ (American Association for Health Education)

www.aahperd.org/naspe/template.cfm (National Association for Sport and Physical Education)

www.cdc.gov/ (Centers for Disease Control and Prevention)

www.bam.gov/about/index.htm

www.bam.gov/fit4life/calendar/index_quiz.asp

www.bam.gov/fit4life/treats_dessert_two.htm

www.cdc.gov/nccdphp/dnpa/5aday/pdf/5_a_day_energizing_tips.pdf

www.cdc.gov/nccdphp/dnpa/5aday/month/beans.htm

www.cspinet.org/ (Center for Science in the Public Interest)

www.ncte.org/standards (National Council for Teachers of English)

www.nsta.org/standards (National Science Teachers Association)

www.paralink.com (Free on-line translations)

www.reading.org (International Reading Association)

www.socialstudies.org/standards/strands/ (National Council for the Social Studies)

www.standards.nctm.org (National Council of Teachers of Mathematics)

Resource D: Spanish Translations of Invitations

Dear Teachers,

The invitations for each of the Family Nights have been translated into Spanish because we know there are many Spanish-speaking families in our nation. You will notice that some letters begin with "Querida Famila" while others begin with "Estimada Familia." The former greeting is more casual and personal and should be used after you already know the family. For the first invitation, we recommend using "Estimada Familia."

¡Ven y haz un Álbum familiar!

Fecha _____

Querida familia,

Los invitamos:

 A:　　　La noche del álbum familiar: Conservar recuerdos en palabras y fotografías.

 A quiénes: Padres o tutores y niños.

 Fecha:

 Hora:

 Lugar:

 Motivo:　Para crear un álbum de fotos para preservar recuerdos familiares y para conocernos mejor.

Habrá botana y bebidas gratis.

Traigan fotografías y/o otros recuerdos de su familia que se puedan usar para crear un álbum familiar.

Por favor, ¡regrésanos la siguiente forma para que sepamos que vendrán!

--

¡SÍ! Mi familia y yo iremos a la noche del álbum familiar: Conservar recuerdos en

Palabras y Fotografías el día _____.

_____　　　　_____
(Nombre del alumno)　　　　　　　(Número de asistentes)

¡Venga y escuche a su niño leer!

Fecha _____

Querida familia,

Los invitamos:

A: Libros, libros y más libros: una noche familiar enfocada a la lectura.

A quiénes: Padres o tutores y estudiantes.

Fecha:

Hora:

Lugar:

Motivo: Para aprender a ayudar a su hijo con la lectura y ¡para divertirse!

 ¡Los niños harán toda la lectura!

Habrá un pequeño refrigerio y bebidas. No tienen que traer nada. Por favor, regrésenos la siguiente forma si asistirá.

¡SÍ! Mi familia y yo asistiremos a Libros, Libros y más Libros: Una noche enfocada a la lectura el día _____.

_____ _____
(Nombre del alumno) (Número de asistentes)

¡Ven y comparte tu mascota!

Fecha _____

Querida familia,

Los invitamos:

A: La noche familiar "Conoce nuestras mascotas."

A quiénes: Padres o tutores y estudiantes.

Fecha:

Hora:

Lugar:

Motivo: Compartir la mascota con los compañeros de clase y sus
 familias y/o para aprender a cerca de las mascotas de
 otros estudiantes en la clase.

Habrá botanas gratis. No debes traer más que tu mascota o la fotografía de
una. Por favor, regrésanos la forma si asistirás.

--

¡SÍ! Mi familia y yo asistiremos a la noche familiar "Conoce nuestras
mascotas" el día _____.

_____ _____

(Nombre del alumno) (Número de asistentes)

Nosotros (LLEVAREMOS o NO LLEVAREMOS) nuestra mascota para
compartirla. (Encierra en un círculo LLEVAREMOS o NO LLEVAREMOS).

Nuestra mascota es _____.

_____ No tenemos mascota pero nos gustaría compartir la experiencia
de una mascota que tuvimos o que esperamos tener.

¡Ven y juega algunos juegos para aprender algo de matemáticas!

Fecha _____

Querida familia,

Los invitamos:

A: Una mañana de diversión familiar con matemáticas.

A quiénes: Padres o tutores y estudiantes.

Fecha:

Hora:

Lugar:

Motivo: ¡Aprender algunos juegos de matemáticas para jugar en la escuela y en casa!

Se servirá cereal, café, leche, y jugo.

Trae a toda tu familia.

Por favor, regrésanos la siguiente forma si podrás venir.

--

¡SÍ! Mi familia y yo asistiremos a la mañana de diversión familiar con matemáticas el día _____.

_____　　　　_____

(Nombre del alumno)　　　　　　　　　　　(Número de asistentes)

¡Venga y comparta historias y tradiciones con su niño/a!

Fecha _____

Querida familia,

Los invitamos:

A: Una noche para compartir historias familiares y tradiciones.

A quiénes: Padres o tutores y estudiantes.

Fecha:

Hora:

Lugar:

Motivo: Para disfrutar una agradable comida con amigos y para compartir y aprender de nuestras múltiples historias familiares y tradiciones.

Trae el paltillo favorito de tu familia para nuestra cena. Bebidas gratis.

Por favor regrésanos la siguiente forma si asistirás.

¡SÍ! Mi familia y yo asistiremos a la noche para compartir historias familiares y tradiciones el día _____.

_____ _____

(Nombre del alumno) (Número de asistentes)

¡Ven y planeemos juntos divertidas actividades de escritura!

Fecha _____

Querida familia,

Los invitamos:

A: Una noche familiar de elaborar un juego para desarrollar habilidades de escritura.

A quiénes: Padres o tutores y estudiantes.

Fecha:

Hora:

Lugar:

Motivo: Para crear un juego de Bingo (Lotería) con actividades de escritura para que su niño juegue en casa.

Habrá un pequeño refrigerio.
¡No tiene que traer nada!

Por favor regrésenos la siguiente forma si asistirá.

¡SÍ! Mi familia y yo asistiremos a la noche familiar de elaborar un juego para desarrollar habilidades de escritura el día _____.

_____ _____

(Nombre del alumno) (Número de asistentes)

¡Ven a una pijamada!

Fecha _____

Querida familia,

Los invitamos:

A: Una pijamada familiar: Un evento de lectura.

A quiénes: Padres o tutores y estudiantes.

Fecha:

Hora:

Lugar:

Motivo: Para acercarse con excelentes libros.

 ¡Los niños harán toda la lectura!

Habrá chocolate caliente y festín.

Si deseas, ponte tu pijama más cómoda y trae tu muñeco de peluche favorito o sábana.

¡trae a toda tu familia!

Por favor regrésenos la siguiente forma si asistirá.

--

¡SÍ! Mi familia y yo asistiremos a la pijamada familiar: un evento de lectura el día _____.

_____ _____

(Nombre del alumno) (Número de asistentes)

¡Vengan y aprendan acerca de la gente famosa!

Fecha _____

Estimada familia:

Los invitamos:

A: Una noche familiar para conocer a gente famosa a través de biografias.

A quiénes: Padres / tutores y niños.

Fecha:

Hora:

Lugar:

Motivo: Leer acerca de las vidas de personas quienes han hecho la diferencia. Niños o adultos pueden participar en la lectura.

Se dará comida y bebidas. No necesitan traer nada.

Por favor regrese esta forma si va a asistir.

--

Sí, mi familia asistirá a la noche para conocer a gente famosa a través de biografías el día _____.

Mi persona favorita de la que me gustaría saber más es: _____

_____ _____
(Nombre del alumno) (Número de asistentes)

¡Vengan a compartir sus aficiones, talento o intereses!

Fecha _____

Estimada familia:

Estamos planeando una noche familiar para compartir aficiones, talentos, e intereses, en la que nos gustaría intercambiar sus colecciones, habilidades, aficiones, intereses o profesiones. ¿Tiene una colección interesante de algo que a otras personas les gustaría ver o escuchar?, ¿Tienes una afición que podrías compartir?, ¿Qué trabajo tiene que podría interesar a los compañeros de clase de su hijo y sus familias? Por favor considere compartir su colección, habilidades, aficiones, intereses, o profesión en este evento a llevarse a cabo:

_____(fecha) en _____(lugar)

Esperamos que las familias van a compartir su experiencia en una plática o demostración de 10 min. Ayudará a tener algo que mostrar. Será muy informal. Dejen un poco de tiempo para preguntas después de su presentación. Si alguien de su familia o tal vez todos, están dispuestos a compartir, por favor llenen la forma y regrésenla con su hijo.

Sinceramente,

Sí, me gustaría compartir algo en la noche familiar de aficiones, talentos, e intereses.

Yo voy a compartir _____

Mi nombre es _____ y soy un miembro de la familia de

_____ Mi número de teléfono es: _____.
(Nombre de la familia)

¡Vengan y diviértanse disfrutando de la poesía juntos!

Fecha_____

Estimada familia:

Los invitamos:

A: Lectura, escritura, mañana familiar de poesía viva.

A quiénes: Padres/tutores y niños.

Fecha:

Hora:

Lugar:

Motivo: Para escuchar y leer poesía juntos y, si quieren, crear un poema nuevo.

Todas las lecturas y escrituras son opcionales. Disfrutar de la poesía es escucharla al ser declamada. Se dará un desayuno ligero y café. No necesita traer nada.

Por favor regrese esta forma si va a asistir.

¡Sí! mi familia y yo asistiremos a la mañana familiar de lectura, escritura y poesía en vivo, el día _____.

_____ _____

(Nombre del alumno) (Número de asistentes)

¡Vengan y exploren el mundo juntos!

Fecha _____

Estimada familia:

Los invitamos:

A: Noche para hacer la ciencia divertida.

A quiénes: Padres/tutores y niños.

Fecha:

Hora:

Lugar:

Motivo: Para hacer que los padres y niños exploren la materia física en su medio y aprendan conceptos de ciencia, principios, y lenguaje.

Se dará una cena ligera y bebidas.

Parde conseguir. Necesitan traer: un martillo, un tazón grande o cubeta, una toalla de cocina vieja, y una tapa de pluma (como de las plumas "Bic"). También, traigan doce cosas pequeñas de la casa y que no les importe perder. Puedes escoger lo que sea. Un buen ejemplo sería: un palo, una piedra, una aspirina, una botella de plástico, una vela, un crayón, una llave, una barra de jabón, una nuez, algo de cerámica, una cuchara de madera, un espejo, un clavo, un mármol, una pluma, una pelota de papel, una barra de goma, un juguete pequeño. No traigan nada valioso.

Por favor regresen esta forma si van a estar ahí.

¡Sí! mi familia y yo asistiremos a la noche familiar para hacer la ciencia divertida el día _____.

_____ _____
(Nombre del alumno) (Número de asistentes)

¡Venga y comparta algunos chistes, acertijos, y caricaturas con su niño!

Fecha _____

Estimada Familia:

Los invitamos:

A: Diversión con el idioma: Una noche familiar de chistes, acertijos y caricaturas.

A quiénes: Padres/tutores y niños.

Fecha:

Hora:

Lugar:

Motivo: Para divertirse con el idioma de los chistes, acertijos, y caricaturas y crear algunos también.

Se dará una comida ligera y bebidas. No necesita traer nada. Si tienen un chiste, acertijo, o caricatura favorita, esté preparado para compartirlo. (Asegúrese de que no va a ofender a nadie)

Por favor regrese esta forma si va a estar ahí.

¡SÍ!, mi familia y yo vamos a asistir a la noche familiar de chistes, acertijos, caricaturas el día _____.

_____ _____

(Nombre del alumno) (Número de asistentes)

¡Venga y vuélvase más saludable con su niño!

Fecha _____

Estimada Familia:

Los invitamos:

A: Noche de salud y bienestar familiar.

A quiénes: Padres / tutores y niños.

Fecha:

Hora:

Lugar:

Motivo: para aprender como todos (maestros incluidos) podemos
 tener un estilo de vida más saludable.

Sé dará un comida ligera. No necesita traer nada. Por favor regrese este
formato si van a estar ahí.

--

¡SÍ!, mi familia y yo asistiremos a la noche de salud y bienestar familiar el

_____.

_____ _____
(Nombre del alumno) (Número de asistentes)

References

Adger, C.T., & Locke, J. (2000). *Broadening the base: School/community partnerships serving language minority students at risk.* Santa Cruz, CA: Center for Research on Education, Diversity, and Excellence (http://www.crede.org).

Chang, J.-M. (2004). *Family literacy nights: Building the circle of supporters within and beyond school for middle school English language learners.* Santa Cruz, CA: Center for Research on Education, Diversity, and Excellence (http://www.crede.org).

Clark, R. (2002). Ten hypotheses about what predicts student achievement for African American students and all other students: What the research shows. In W. R. Allen, M. B. Spencer, & C. O'Conner (Eds.), *African American education: Race, community, inequality, and achievement: A tribute to Edgar G. Epps.* Oxford, UK: Elsevier Science.

Cooper, C., Chavira, G., & Mena, D. (2004). How diverse families, schools, and communities support children's successful pathways through school: A synthesis for research, practice, and policy. Santa Cruz, CA: Center for Research on Education, Diversity, and Excellence (http://www.crede.org).

Epstein, J. (1987). Toward a theory of family-school connections: Teacher practices and parent involvement. In K. Hurrelmann, F. Kaufmann, & F. Losel (Eds.), *Social intervention: Potential and constraints* (pp. 121–136). New York: DeGruyter.

Epstein, J. L. (1995). School/family/community partnerships: Caring for the children we share. *Phi Delta Kappan, 76,* 701–712.

Epstein, J., Coates, L., Salinas, K., Sanders, M., & Simon, B. (1997). *School, family, and community partnerships: Your handbook for action, 2nd edition.* Thousand Oaks, CA: Corwin.

Kyle, D., McIntyre, E., Miller, K., & Moore, G. (2002). *Reaching out: A K–8 resource for connecting schools and families.* Thousand Oaks, CA: Corwin.

Marcon, R. (1999). Positive relationships between parent school involvement and public school inner-city preschoolers' development and academic performance. *School Psychology Review, 28*(3), 395–412.

McIntyre, E., Rosebery, A., & González, N. (2002). *Classroom diversity: Connecting curriculum to the lives of students.* Portsmouth, NH: Heinemann.

Moll, L.C., & González, N. (2003). Engaging life: A funds of knowledge approach to multicultural education. In J. Banks & C. A. Banks (Eds.), *Handbook of Multicultural Education* (pp. 699–715). San Francisco: Jossey-Bass.

National Council for the Social Studies (1994). *Curriculum standards for social studies: Expectations of excellence.* Silver Springs, MD: National Council for the Social Studies.

National Council of Teachers of Mathematics (2004). *Principles and standards for school mathematics.* Reston, VA: National Council of Teachers of Mathematics.

National Reading Panel Report (2000). *Teaching children to read: Report of the subgroups.* Washington, DC: National Institute of Child Health and Human Development.

National Research Council (1996). *National science education standards.* Washington, DC: National Academy Press.

NCTE/IRA Standards for English/Language Arts. (2002) (http://www.ncte.org).

Sanders, M., & Epstein, J. (2000). The national network of partnership schools: How research influences educational practice. *Journal of Education for Students Placed at Risk, 5,* 61–76.

Sanders, M., & Herting, J. (2000). Gender and the effects of school, family, and church support on the academic achievement of African-American urban adolescents. In M.G. Sanders (Ed.), *Schooling students placed at risk: Research, policy, and practice in the education of poor and minority adolescents* (pp. 141–161). Mahwah, NJ: Lawrence Erlbaum.

Shaver, A., & Walls, R. (1998). Effect of Title I parent involvement on student reading and mathematics achievement. *Journal of Research and Development in Education, 31*(2), 90-97.

Tharp, R.G., & Gallimore, R. (1993). *Rousing minds to life: Teaching, learning, and schooling in social context.* Cambridge, U.K.: Cambridge University Press.

Vygotsky, L.S. (1978). *Mind in society: The development of higher psychological processes.* Cambridge, MA: Harvard University Press.

Index